IMAGES
of America

AIKEN

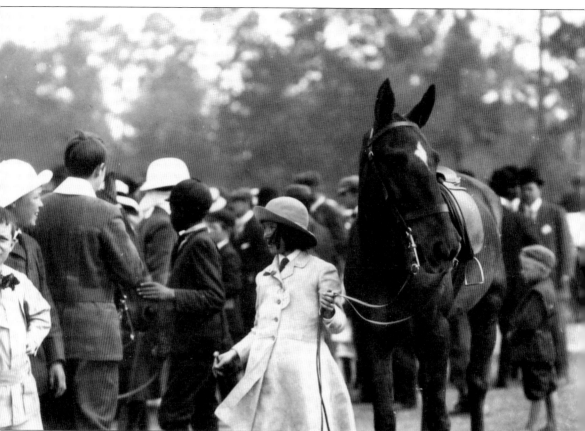

Horses have been a central part of the Aiken community since the arrival of the first Winter Colonists. This photograph from an early Aiken Horse Show also illustrates just how important it was to the colonists that equestrian traditions were carried on by their children. This young girl is undaunted by the size of her steed, and the crowd consists of her young peers. (South Caroliniana Library, University of South Carolina, Columbia.)

ON THE COVER: Carroll Bassett (left) and Dunbar Bostwick compete in one of the first Aiken Steeplechase competitions. Steeplechase was founded in Aiken in 1930 and followed the Aiken Hound Drag lines in Hitchcock Woods. Bassett was considered one of the top steeplechasers of the time and was later inducted into the National Steeplechase Hall of Fame. Bostwick was also a legendary horseman, having founded the Aiken Mile Track for harness racing. (South Caroliniana Library, University of South Carolina, Columbia.)

IMAGES of America
AIKEN

Janice McDonald and Paul Miles

Copyright © 2011 by Janice McDonald and Paul Miles
ISBN 978-0-7385-8736-3

Published by Arcadia Publishing
Charleston, South Carolina

Printed in the United States of America

Library of Congress Control Number: 210936917

For all general information, please contact Arcadia Publishing:
Telephone 843-853-2070
Fax 843-853-0044
E-mail sales@arcadiapublishing.com
For customer service and orders:
Toll-Free 1-888-313-2665

Visit us on the Internet at www.arcadiapublishing.com

To our father and grandfather, Weyman T. McDonald Sr., whose memory has given us a love for the things in the past that count

Contents

Acknowledgments		6
Introduction		7
1.	This Place	9
2.	Civil War and the Battle of Aiken	25
3.	The Winter Colony	33
4.	Sport Center of the South	57
5.	Aiken and Its People	93
Photograph Index		127

Acknowledgments

Writing this book has been a treasure hunt back through time to discover those little tidbits of information about the people and events that shaped Aiken into the incredible town it is today. Looking through old newspapers and magazines and talking to those who lived it, or parents and grandparents living it, was an amazing experience.

We would like to thank the many people who endured our countless phone calls, e-mails, texts, and visits to fact check or find "just one more photograph." So many of you spent time you didn't have because you cared about sharing the story of Aiken. Many thanks to Paula, David, and Ryan Miles for acting as sounding boards, offering advice for other sources, and running around when we couldn't. Lesta Sue Hardee, once again, you got us through. To Bill Babb, we need that set of eyes. Lisa Hall, Brenda Baratto, and Elliott Levy, you did so much when we were backing up against the deadline. Others behind the scenes include Beth Bilderback, Rob Harrington, Christi Koelker, Mary M. Lehr, Coleen Reed, Mary White, and of course, our editors Lindsay Carter and Maggie Bullwinkle.

The images in this book include several in the public domain. Unless otherwise credited, all photographs are the property of the authors. Those that have been provided to us are noted and appear courtesy of Aiken County Library, Aiken County Historical Museum (ACHM); Aiken Preparatory School; Aiken Thoroughbred Racing Hall of Fame and Museum (Hall of Fame); Samuel L. Boylston; Center for African American History, Art and Culture (CAAHAC); Gary Dexter; Lisa Hall; Gregg-Graniteville Archives, Gregg-Graniteville Library, University of South Carolina Aiken (Gregg); Hitchcock Woods Foundation; The Library of Congress (LOC), Todd Lista of Lista Studios (Lista); Paul Miles (PM), Ryan Miles (RM); Palmetto Golf Course (Palmetto); Courtney Armour Regan (CAR); Fraser Sofage; South Carolina Department of Archives and History (SCDAH); South Caroliniana Library, University of South Carolina, Columbia (Caroliniana); Jane Page Thompson (JPT); Strom Thurmond Collection, Clemson University (Thurmond); and United States Department of Energy (DOE).

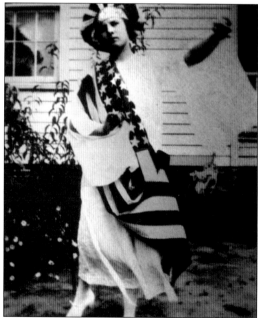

Theme parties were the rage in the early 1920s when Maude Johnson Mims donned this patriotic ensemble. (Lisa Hall.)

INTRODUCTION

Though it is a bit off the beaten path, for decades and even centuries, many people have sought out Aiken, South Carolina, as the place to be. The quiet beauty of the area with its stately oaks and fragrant pines is unsurpassed. Special geographical and climatological features have helped establish a community and lifestyle that has set this place apart. For well over 100 years, Aiken has been known as the "Winter Colony," a homage to the fact that the well-heeled would congregate in this unassuming area to escape the Northern cold; however, Aiken's claim on history goes far beyond this nickname.

Native Americans were the first to stake claim in the region, coming to the area midway between mountains and seashore to endure winters. The temperate climate and abundant springs were also appealing to European settlers, who felt that living in the area was not just desirable, but good for their health.

In the early 1800s, the fields around the tiny town were blanketed with growing bolls of cotton. The term "cotton is king" was first coined by Aiken neighbor John Henry Hammond. Looking for an economic way to get their crops to market, a group of plantation owners worked to build a railroad to the sea, where their cotton would then be shipped around the world.

The name Aiken itself pays tribute to William Aiken, who in 1827 helped charter the South Carolina Canal and Railroad Company connecting Charleston to Hamburg. Ironically, Aiken died before the rail line could be completed after a train whistle spooked the horse pulling his carriage. The line was an ambitious gamble that paid off. The rail enterprise produced the longest steam railroad in the world and soon changed the face of what until then had been only a small crossroads community.

While the rail was established to help transport cotton and other products, it also opened the door for tourists who came to take advantage of the temperate climate. The region began advertising itself as a health resort, inviting visitors to come breathe the "fresh piney air." People began to heed the call, and soon Aiken was hosting those who wanted to reap the benefits of such a healthful community.

That growth was interrupted by the Civil War. Near the conflict's end, Aiken became the site of a vicious battle and one of the South's few decisive victories. With Gen. William T. Sherman determined to make South Carolina pay for seceding from the Union, he sent one of his most brutal generals, Maj. Gen. Hugh Judson Kilpatrick, to Aiken to destroy it and nearby mills. Confederate general Joseph "Fightin' Joe" Wheeler was determined not to let that happen. In a fight on the streets of Aiken, which in some cases resulted in hand-to-hand struggles, Wheeler was able to thwart Kilpatrick's efforts, leaving the Union general's cavalry in complete disarray. Kilpatrick fully withdrew from the region, a small but important victory for the Confederacy.

After the war and the rebuilding of Aiken's railroad, tourists returned and brought with them a great prosperity for the region. Initially coming for health reasons, a growing group of wealthy businessmen discovered Aiken to be an ideal place to raise horses. Grand inns, mansions, and enclaves were built as Aiken became known as the "Winter Colony" for the rich and famous.

Lead by the seemingly tireless couple Thomas and Louise Hitchcock, the colonists created a playground for themselves. William C. Whitney joined the Hitchcocks in purchasing 8,000 acres of land to be used for sporting activities. A part of this property is today's Hitchcock Woods, the largest urban forest in the United States.

The Hitchcocks' and Whitney's vision for Aiken and its people had a lasting impact on today's community. Responding to their invitation, visitors began arriving by the trainloads to escape Northern winters and enjoy outdoor sports of every imaginable form. Society columns of Northern newspapers and magazines kept a close eye on the activities of the small town that they were calling the "Newport of the South." At one point there was even direct rail service from New

York City's Penn Station to downtown Aiken. Vanderbilt, Post, and Astor were just some of the names associated with industry leaders who were regulars in Aiken. They were joined by a host of celebrities and politicians. Franklin Delano Roosevelt's private railcar would deposit him at the private entrance to the Willcox Hotel.

Aiken's climate and terrain were deemed unmatched when it came to raising and training horses. Many of the nation's equestrian activities were shaped by the people and events in Aiken. Horse shows, races, steeplechase, and polo still bring visitors from throughout the world to be a part of some of the internationally recognized competitions that take place.

Another important sport to the people of Aiken is golf. Built in 1892 by Thomas Hitchcock, Palmetto Golf Club was one of the first golf courses built in the South. To this day, it remains one of the country's most respected clubs and is the oldest 18-hole course to continue to operate in the same location.

Many Winter Colonists put down roots in the community, building hospitals and schools, and establishing the town's fire department. Louise Hitchcock established a private school, Aiken Preparatory. Considered one of the best private schools in the United States, Aiken Prep is the only junior boarding school in the Southeast.

The cold war changed the look of the region when the U.S. Atomic Energy Commission chose Aiken, Barnwell, and Allendale counties to create a repository for nuclear waste. The government bought all of the land of the small town of Ellenton and displaced its residents to establish what is now the Savannah River Site. SRS is one of Aiken's largest employers.

The Aiken of today is a thriving community that holds fast to the genteel lifestyle around which it grew. With so many streets in the downtown historic area still unpaved, it's easy to get a glimpse of the past as you watch riders walking their horses toward Hitchcock Woods or see a carriage making its way along one of the wide tree-lined avenues. Visitors to this historic Southern town will find themselves welcomed by both the past and the present when they see the tree-lined streets and historic homes and estates—and when they take in the scent of that piney air, which still exists along with the smells of gardenia and magnolias.

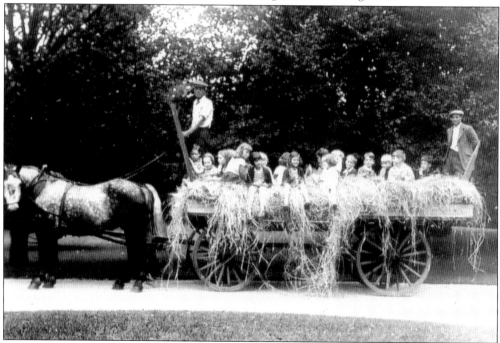

A group of children of the Winter Colonists enjoy a hayride on the grounds of Joye Cottage. (CAR.)

One
THIS PLACE

The first recorded accounts of Europeans visiting the lands around present day Aiken detailed the arrival in 1540 by Spanish explorer Hernando DeSoto. Coming north from Florida and crossing the Savannah River near Silver Bluff, he was welcomed with a gift of pearls by Native American Cofitachiqui Queen Xualla. DeSoto repaid her kindness by taking her hostage. Unable to find the riches he had hoped for, DeSoto eventually allowed Xualla to escape.

DeSoto raided the Cofitachiqui temple mounds in search of treasures to take back to the King of Spain. Inside, he found 14 bushels of pearls and evidence of earlier Europeans—possibly Lucas Vasquez de Ayllon, who had attempted a settlement in Winyah Bay. Finding no gold, DeSoto had the mounds destroyed. The Cofitachiqui are believed to have lived in the region for more than 400 years before disappearing in the late 1600s.

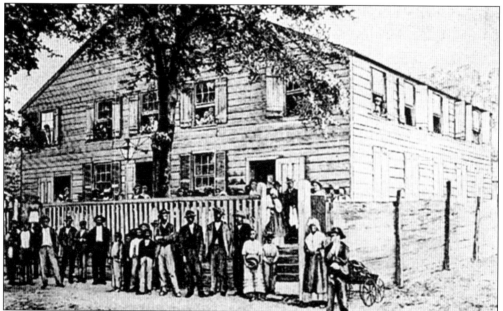

One of the first black Baptist churches in the United States and the first in South Carolina was founded in an area called Silver Bluff, in present-day Aiken County. Founded in 1773, the congregation included both freed blacks and slaves. Preacher George Liele became known for his travels throughout the South and his work to establish black Baptist congregations. (ACHM.)

These two images include both the full and a small portion of what is described as, "An Accurate Map of North and South Carolina With Their Indian Frontiers." Created by South Carolina native and Revolutionary War patriot Henry Mouzon, the map was published in 1775. It depicts in intricate detail not only the towns and settlements, but the names of the key landholders in some areas. The map shows the area called New Windsor on the Savannah River, which in 1730 was one of 11 townships ordered created by the king of England's royal governor of South Carolina, Robert Johnson. The New Windsor Township included both Fort Moore and the settlement of Savanna, near present-day Aiken. The fort had been built in 1716 to help control the Savannahs, Creeks, Choctaws, Chickasaws, and Lower Cherokees. It was abandoned in 1763. (Both LOC, Geography and Map Division.)

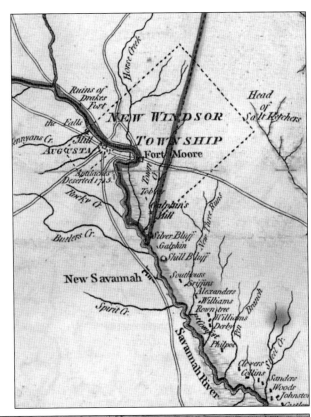

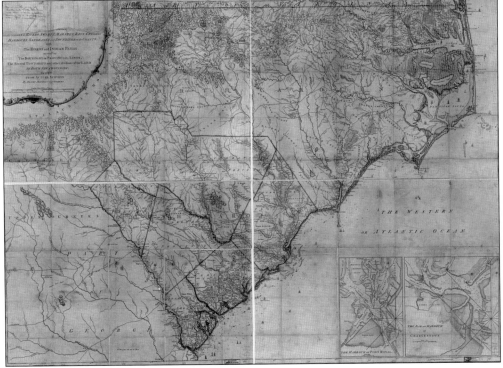

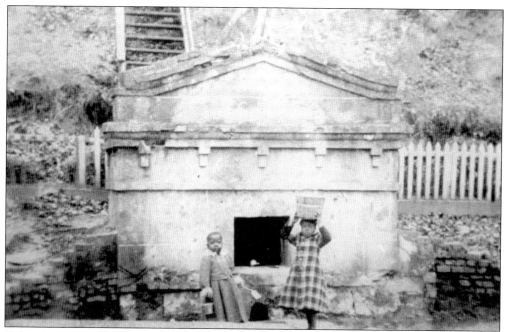

Coker Springs could easily be considered Aiken's first landmark. Archeological evidence suggests this freshwater spring was first used over a millennium ago by prehistoric tribes in the area. Shown here in the late 1800s, the spring's first recorded owner was Ephraim Franklin, who received it as part of a 285-acre land grant in 1787. It gained prominence in the early 1800s as a regular stop for the stagecoach from Abbeville to Charleston, and when the City of Aiken gained its charter in 1835, Coker was the town's main source of fresh water. The brick springhouse, covered in stucco, was built sometime in the mid-1800s, and a separate horse trough was constructed along the side. The location was also used as a prime site for mustering Confederate soldiers into service in Aiken during the Civil War. (ACHM.)

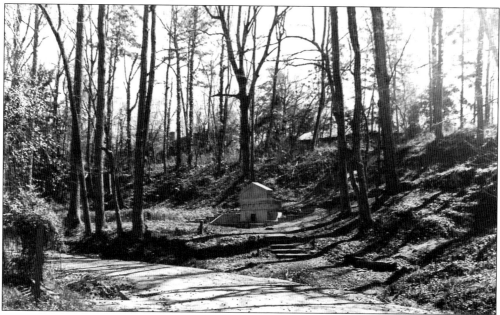

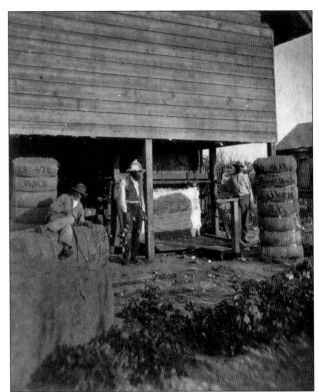

The area of South Carolina surrounding Aiken was largely agricultural in the early 1800s, and cotton was quickly becoming the primary crop. Harvested by hand, plantation owners turned to slaves for manpower. In 1803 alone, more than 20,000 slaves were brought into South Carolina and Georgia to work the cotton fields. (Caroliniana.)

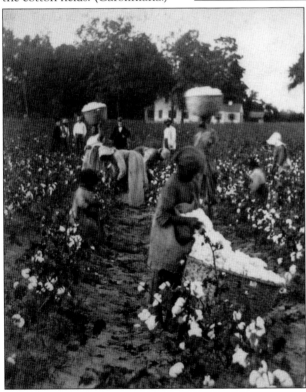

This cotton press photograph shows bales of cotton being prepared for the market. Shipping the cotton to Charleston or Savannah was a costly proposition. As demand for the crop grew, plantation owners began looking for an alternative to floating goods by boat down the Savannah. Surveyors were hired to look at the feasibility of developing rail service to the coast. (Caroliniana.)

Built in 1824, this former farmhouse was part of the cotton plantation called Chinaberry, owned by Capt. William White Williams. Williams also owned interest in the South Carolina Railroad Company. Railroad surveyor Alfred Dexter felt the steep grade into Aiken made a railroad along the route impossible. After falling in love with William's daughter Sarah, Dexter calculated a way to build the line within 100 yards of William's cotton fields. (RM.)

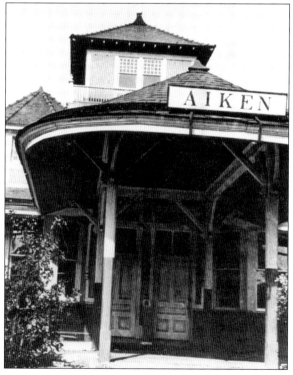

Aiken was named after William Aiken Sr., who helped charter the South Carolina Canal and Railroad Company in 1827 along with a group of businessmen. A successful cotton planter, he was the company's first president. In 1831, two years before the connection between Charleston and Hamburg was completed, Aiken was killed in a carriage accident in Charleston when his horse became frightened by a train. (Lista.)

When the 136-mile track between Charleston and Hamburg through Aiken was laid in the 1830s, it was the longest railroad in the world. The route was surveyed by French engineer James Achille de Caradeuc, with Alfred Dexter of Boston and Cyril Ovear Pascalis of New York overseeing the Aiken portion of the construction. (ACHM.)

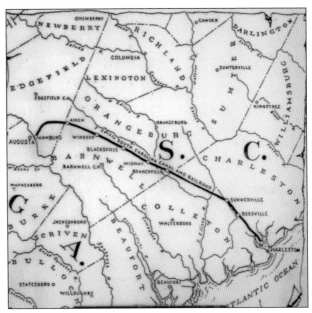

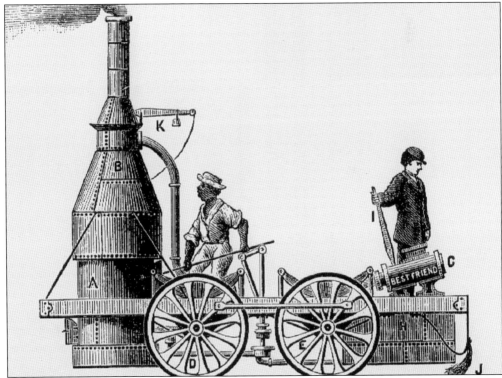

The South Carolina Railroad Company's "Best Friend of Charleston" is characterized on its inaugural Charleston to Summerville run on Christmas Eve, 1830. Popular belief is that this steam engine was the first train to arrive in Aiken on October 1, 1833, but the steam engine was destroyed in an explosion a full year before Aiken's train service began. An engine named the "Phoenix" made the Charleston-Aiken journey. (Archives of the Charleston Chapter of the National Railway Historical Society.)

AUGUSTA DIRECTORY.
S. C. C. & R. R. COMPANY.

FARE REDUCED BETWEEN
CHARLESTON AND HAMBURG,
Eight Dollars through.

The Rail Road Passenger Train between Charleston and Hamburg, will leave as follows:

UPWARD.

Not to leave Charleston before	-	-	7 00	A.M.	
" " Summerville,	-	-	8 30		
" " Georges'	-	-	10 00		
" " Branchville,	-	-	11 00		
" " Blackville,	-	-	12 34	P.M.	
" " Aiken,	-	-	2 45		
Arrive at Hamburg not before	-	-	4 00		

DOWNWARDS.

Not leave Hamburg, before	-	-	6 00	A.M.	
" " Aiken,	-	-	7 30		
" " Blackville,	-	-	9 15		
" " Branchville,	-	-	11 00		
" " Georges'	-	-	11 45		
" " Summerville,	-	-	10 00		
Arrive at Charleston not before	-	-	2 15	P.M.	

Speed not over 25 miles an hour. To remain 20 minutes each, for breakfast and dinner, and not longer than 5 minutes for wood and water at any station.

To stop for passengers, when a WHITE FLAG is hoisted, at either of the above stations; and also at Sineaths, Woodstock, Inabinet's, 4 mile T. O., Rives', Grahams, Willerton, Winsor, Johnsons' and Marsh's T. O.

Passengers up will breakfast at Woodstock and dine at Aiken; down, breakfast at Aiken and dine at Charleston.

The South Carolina Canal and Railroad Company's 136 miles of track between Charleston and Hamburg was built at a reported cost of $951,148. Because of a 400-foot incline before Aiken, a stationary engine, located near the intersection of Highland Park Drive and Highland Park Terrace, was used to pull the train up a steep incline so that it could reach Railroad Avenue, now renamed Park Avenue. (Aiken County Library.)

Rail passes like this were issued to passengers traveling between Aiken and Charleston. The train service was originally developed as a more economical alternative to floating goods by boat down the Savannah River but quickly began capitalizing on its passenger service for those wanting to visit the growing health resort. Other names of the railroad included the Charleston to Hamburg Railroad, the South Carolina Railroad, or the Sola.

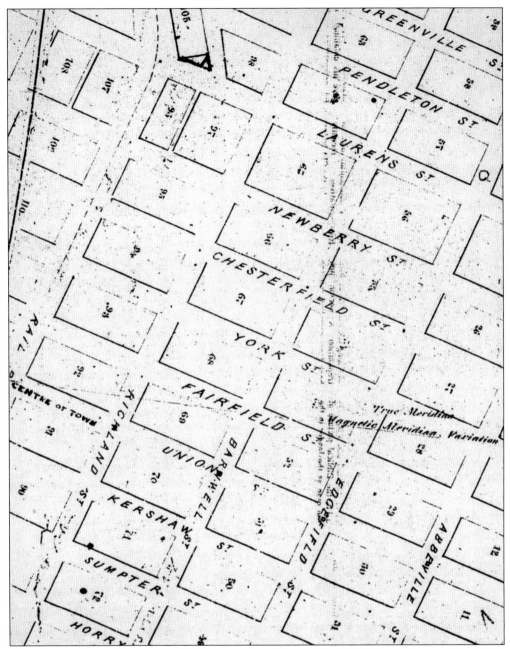

This plat outlining the streets of Aiken was dated September 24, 1834, and created by Alfred Dexter, the same man who surveyed the route for the railroad from Charleston. The land for the new town had been donated to the South Carolina Railroad by Mr. Beverly M. Rodgers. The Town of Aiken received its official charter 14 months later on December 19, 1835. At that time, Aiken was in the Barnwell District. Aiken County would not be established until 1871. Laid out around a core of 27 city blocks, the town was bounded by Edgefield and Railroad (now Park) Avenues and also Newberry and Williamsburg Streets. Their plans allowed for 2 square miles on either side of the track. The center of town was planned around Union Street and Railroad Avenue (now Park Avenue), which is where the railroad depot was located. (ACHM.)

St. Thaddeus Episcopal Church is Aiken's oldest church structure, having had its cornerstone laid on September 5, 1842. The sanctuary was consecrated less than a year later on August 9, 1843. When the South Carolina Canal and Railroad Company laid out its plans for Aiken, it reserved land for churches in the city plans. (Caroliniana.)

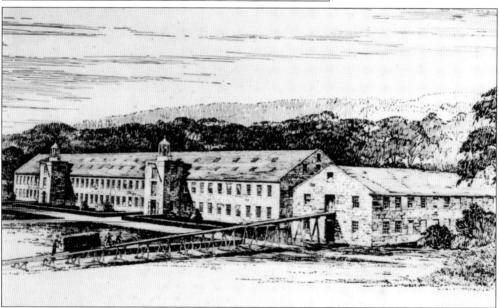

William Gregg was a key figure in founding St. Thaddeus. More notably, Gregg built the first large-scale cotton mill in the South. Located 5 miles from Aiken, Graniteville was chartered in 1845, so named because most of its buildings were constructed of blue granite. Graniteville consisted of 90 homes, several boardinghouses, six stores, two churches, and a school. School was compulsory for all children of mill workers. (Gregg.)

William Gregg can also be credited with helping establish South Carolina as a peach producing state. Having seen the success of Georgia's peaches, he planted more than 8,000 peach trees on his own property at Kalmia Hills plantation. Peaches picked in the morning were shipped by train to Charleston and were sold in New York City by the next day. (Gregg.)

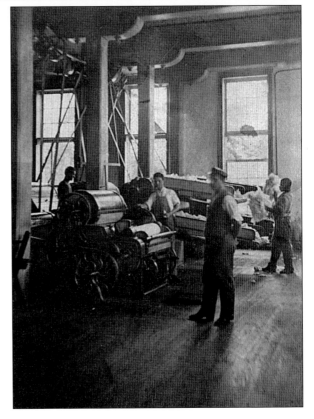

The Langley Cotton Mill was constructed in 1858 on Horse Creek, west of Langley Pond. It was one of several textile mills constructed in the Horse Creek Valley to capitalize on the success of the Graniteville Mills. At its busiest, there were more than 20 mills throughout the valley ranging from textile to paper. The Westos Indians, who lived here, watered their horses in the creek, giving it the name. (Caroliniana.)

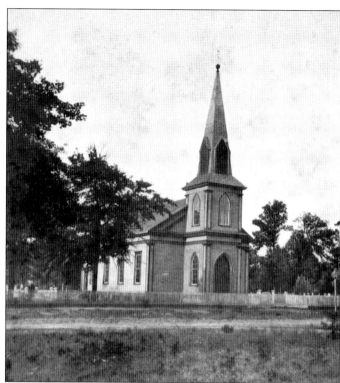

This Aiken Baptist church was formed in 1836 when members of Levels Baptist merged with members of the Wise Creek congregation and built their sanctuary on land deeded by the SC Railroad. Levels had been in existence since 1805 and was located a mile south of present-day Aiken. This wood-frame church burned in 1876 and was replaced in 1878. (Caroliniana.)

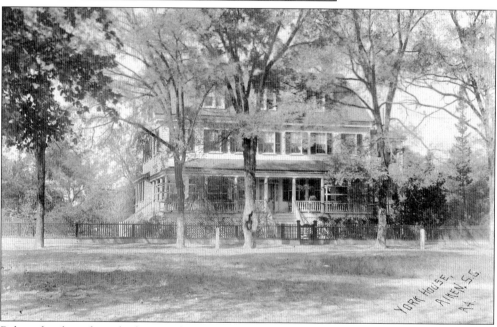

Believed to have been built around 1850, the York House served as an inn for most of its early years, featuring as many as 30 rooms. The owner in 1892 advertised that it had been "thoroughly overhauled," touting the food served at York House as "the best." At one time, the York House was occupied as a winter residence by Mabel Brady Garvan, sister of the legendary "Diamond Jim" Brady. (Caroliniana.)

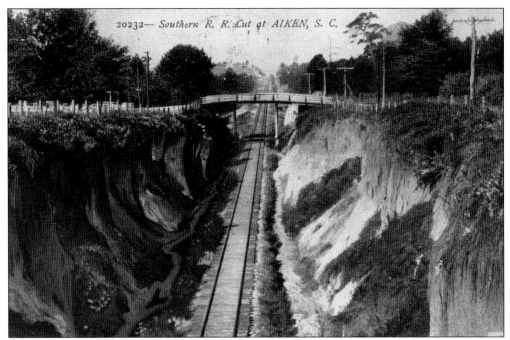

With Aiken growing rapidly, it became impractical to have the busy railroad continually rely on having the trains being pulled up the 400-foot incline into town. In 1852, the line was moved when a "cut" was dug so the engine pulling the trains up the incline was no longer needed. A portion of the original roadbed still exists in Hitchcock Woods.

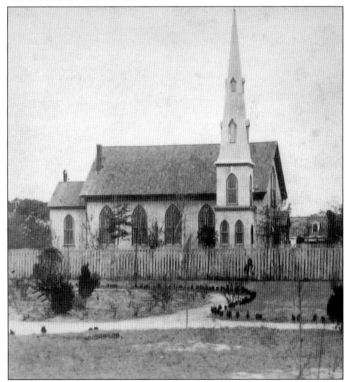

Aiken's first Presbyterian church had just 14 charter members when founded in 1858. The congregation had been meeting in the Aiken Town Hall on Laurens Street before this frame building was constructed in 1859. It was designed by Charleston architect Edward Brickell White with a freestanding steeple. The church stood for 75 years at the corner of Laurens Street and Railroad (now Park) Avenue. It was demolished in 1924. (Caroliniana.)

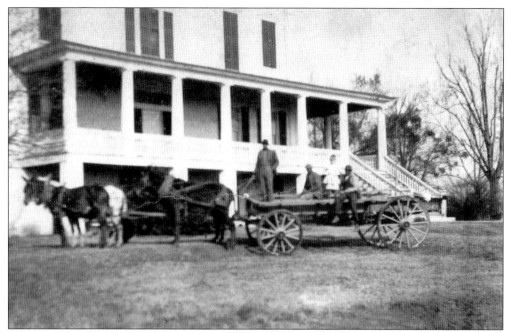

James Henry Hammond is credited with coining the phrase "Cotton is King!" A South Carolina state congressman, governor, and U.S. senator, Hammond built this Greek-Revival mansion just outside of Aiken in Beech Island in 1859. Known as Redcliffe Plantation, three generations of Hammonds descendants lived here before Redcliffe became a state park. (Caroliniana.)

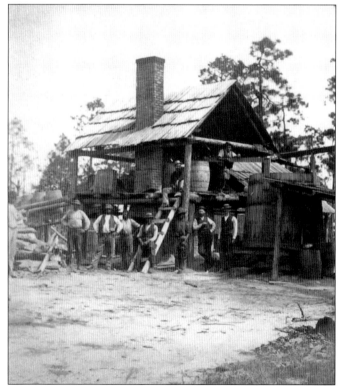

The turpentine business thrived around Aiken for more than a century. The barrels in front of this distillery contain gum drained from yellow pine trees. From March through November, workers would gouge a V-shaped mark on the tree trunk and place a reservoir at the point of the V for sap to flow into. Sap was collected every two to three weeks and taken to the still for processing. (Caroliniana.)

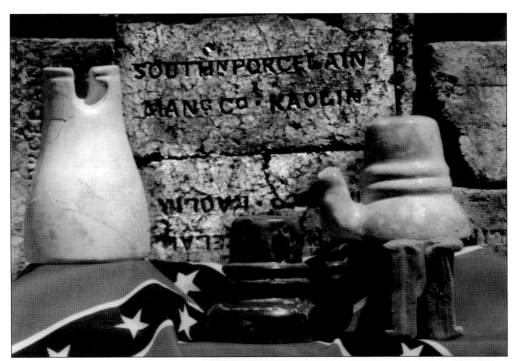

Mining began in 1856 just outside of Aiken for the white clay mineral known as kaolin. Among its many uses is making pottery. That year, William Farrar, a stockholder in the U.S. Pottery Company of Vermont, came south to establish a settlement and a factory to start producing pottery. In 1857, he sold the company, which then became known as the Southern Porcelain Manufacturing Company. Southern Porcelain's products included the porcelain and pottery seen in the photograph above and telegraph insulators for the Confederate government, pictured at right. The factory was destroyed by fire in 1863 and rebuilt following the Civil War. It continued to produce for 12 years before closing. Today 90 percent of the kaolin mined in the United States is mined near Aiken. The world's largest kaolin belt runs between Aiken and Eufaula, Alabama. (Photographs by Gary Dexter.)

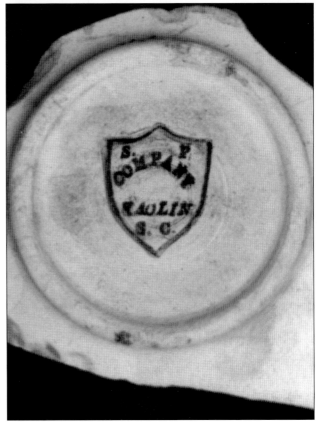

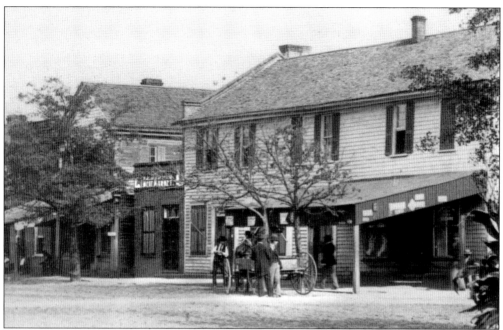

These images of downtown Aiken were taken just prior to the beginning of the Civil War. Some of the local businesses shown include a meat market in the first photograph and a "Bargain Store" in the second. In the mid-1800s, many of the large landholders of Aiken were only part-time residents. In 1860, there were less than 1,000 people living in the town year round, with many of the planter families coming in for the growing season during the summer. Still Aiken was growing, as was its reputation as a health resort. A concerted effort began to spread the word to those living in the North of Aiken's temperate climate. What would come was not the expected increase in summer visitors but a whole different clientele altogether that would change Aiken forever. (Both ACHM.)

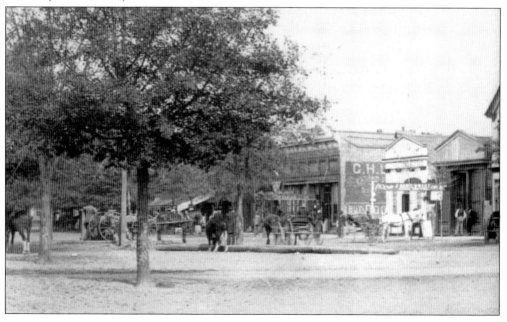

Two

CIVIL WAR AND THE BATTLE OF AIKEN

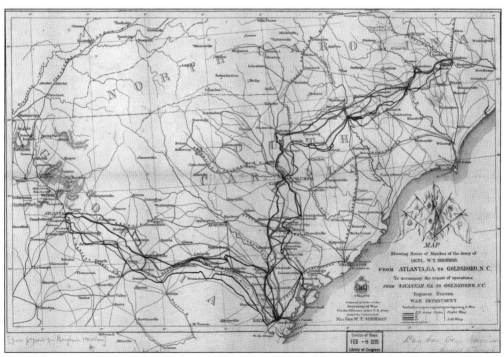

South Carolina was the first state to secede from the United States in the months preceding the Civil War, and for that, Gen. William T. Sherman was determined to make them pay. After his notorious march from Atlanta to Savannah, he targeted the Palmetto State, declaring, "When I go through South Carolina, it will be one of the most horrible things in the world. The devil himself couldn't restrain my men in that state." (LOC.)

When choosing a commander for his cavalry, General Sherman picked the brash and boastful Maj. Gen. Hugh Judson Kilpatrick (shown here a year earlier, fourth from the left). Nicknamed "Killcavalry," he was known for his disregard for his own men while eliminating the enemy at all costs. In South Carolina, Kilpatrick would leave a scorched path, burning homes, mills, and even churches. He referred to the town of Barnwell, South Carolina, to "Burnwell" when corresponding with Sherman. (LOC.)

Gen. Joseph Wheeler had been born in Augusta, Georgia, although he had spent most of his early days in Massachusetts. The West Point graduate had done battle with Sherman's forces in Atlanta and was considered one of the few effective commanders in trying to quell damages during Sherman's March to the Sea and Savannah. In 1865, "Fightin' Joe" Wheeler and his men turned their attention to halting the Carolinas Campaign. (LOC.)

The Carolinas Campaign began February 1, 1865. Sherman kept the Confederacy guessing as to where he would center his attack: Augusta or Charleston. He eventually divided his army, sending troops toward both cities, with his ultimate goal being to take South Carolina's capital, Columbia. General Kirkpatrick, leading the 5th U.S. Calvary, reportedly spent $5,000 of his own money on matches in preparation for the campaign. (ACHM.)

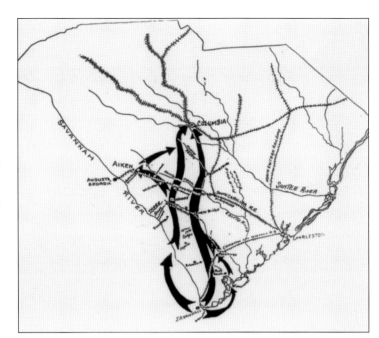

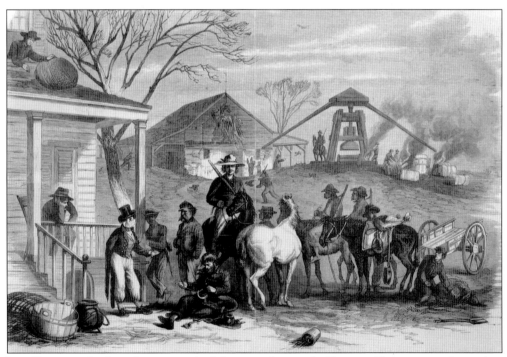

In addition to the fiery destruction laid down in their path, Union soldiers were authorized to "live off the land" by "foraging." They became known as "Sherman's Bummers," derived from the German word "bummler," meaning "drifter" or "laggard." Captured bummers were often hung as arsonists, thieves, and murderers. In 1865, *Frank Leslie's Illustrated Newspaper* portrayed the bummers during the Carolina Campaign. (Caroliniana.)

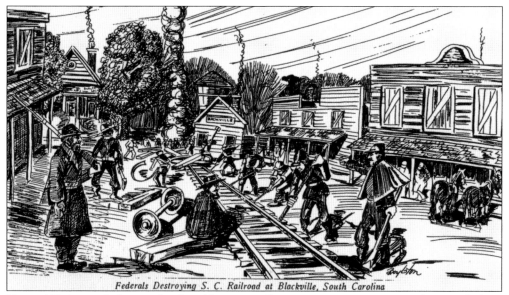

Federals Destroying S. C. Railroad at Blackville, South Carolina

General Kirkpatrick destroyed railroad lines as well as government property on his march from Blackville to Aiken, unsettling the region's infrastructure so that it could not be used after his departure. Sherman had ordered the elimination of as many tracks as possible, having the rails twisted around trees so they could not be re-laid. The twisted metal was referred to as "Sherman's bowties." (Sketches by Samuel Boylston, courtesy Raymond P. Boylston Jr.)

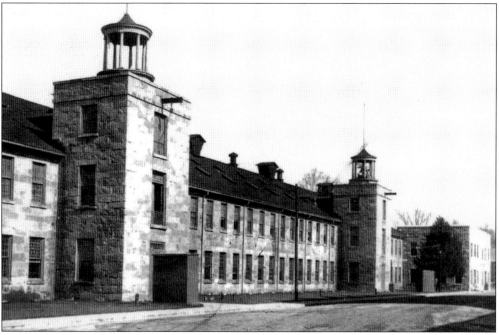

While the Confederate's critical gunpowder mills in Augusta were a prime target for the Union, the Graniteville cotton mills and Bath paper mill also were listed under Sherman's orders for destruction. During the Civil War, the Graniteville mills furnished about 40,000 yards of material a year to the Confederacy, while the Bath mill made paper for Confederate currency. (Fraser Sofage.)

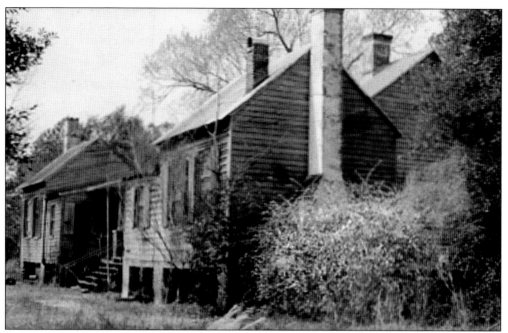

Using Elizabeth Pascalis's Montmorenci home as his headquarters, General Kirkpatrick entered what is now Aiken County near White Pond on February 9. The first actual shots of the Battle of Aiken took place at White Pond, when Col. Charles Crew's regiment of Wheeler's Calvary first engaged Kirkpatrick in a brief skirmish before both sides pulled back to reorganize. (SCDAH.)

General Wheeler used this home at 204 Railroad Avenue (now Park) owned by W. J. Williams while planning how to halt Kilpatrick's advance on Aiken. Wheeler laid a trap by positioning his cavalry in the shape of a V, with Railroad Avenue running down the center. A small line of skirmishers at the top would lure Kilpatrick in, and the Confederates would collapse the V behind him, blocking retreat. (RM.)

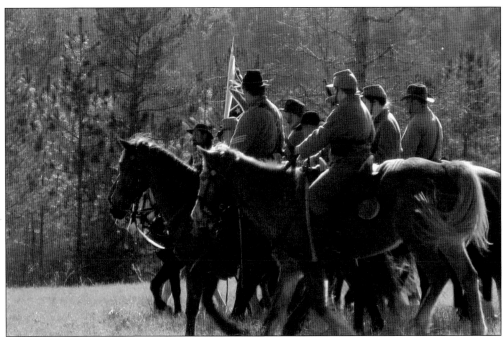

General Wheeler had consolidated a force of 4,500 troops in Aiken by the time Kilpatrick's 2,000 reached the town's outskirts on February 11, 1865. Kilpatrick was warned by locals that Wheeler was waiting on him but had no idea of the size of Wheeler's force. As he confidently marched his men up Railroad, Richland, and Barnwell Avenues, ladies in the town waved their handkerchiefs, shouting welcome to the soldiers. (PM.)

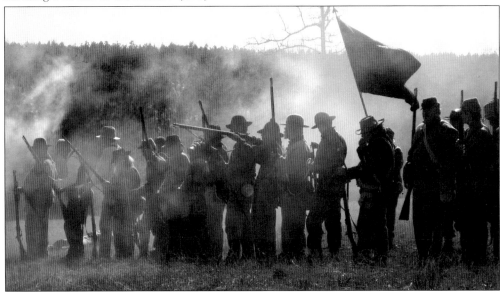

Wheeler's advance picket line waited on Williamsburg Street and fell back as planned towards York Street. The notoriously egotistical Kilpatrick wrongly assumed they were fleeing. During the movement, an Alabama trooper prematurely fired, alerting Kilpatrick to the trap that awaited. Fearing momentum would be lost, Wheeler reacted quickly, sounding the bugle and ordering a full charge of all of his units. (PM.)

General Wheeler had positioned himself to ready for the battle in front of Chinaberry, the W. W. Williams house off South Boundary Avenue. While the main battle raged on, smaller skirmishes took place elsewhere around town. One of those that was considered particularly vicious occurred in what was essentially the Williamses' front yard. (RM.)

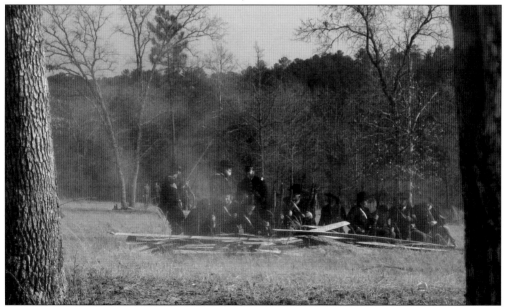

As the Confederate troops called out for their surrender, the Union cavalry charged the lines to try and break through. One Union soldier later recounted the events saying, "It was a desperate charge, and the men fought face to face and hand to hand." Blind confusion reigned in the heat of the battle. Fighting raged for a full day until the Union forces began to break loose and flee Aiken. (PM.)

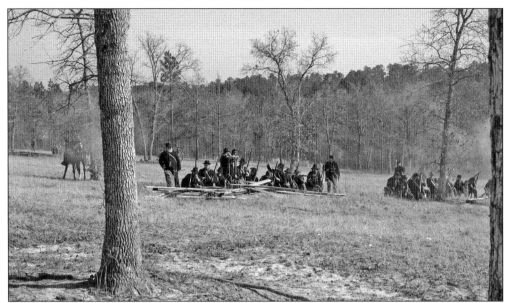

When the Union began to retreat, the Aiken Home Guard continued to skirmish with them until they were driven back to Montmorenci. Kilpatrick's own accounts detailed confusion in the pullback. He even lost his hat during the rush. The following day, Kilpatrick sent out a flag of truce to exchange and recover the dead or wounded. On February 13, the Union cavalry moved to rejoin Sherman on the march to Columbia. (PM.)

Twenty Union soldiers were buried in the First Baptist Church's graveyard, while two Tennessee Cavalrymen of the Confederacy lie in the cemetery of St. Thaddeus. Exact figures of casualties are unknown. The Union lost between 45 and 495 men. Between 50 and 251 Confederates died. The Union cavalry was left in disarray, and Aiken and the mills were safe. However, it would be three years before railroad service returned to Aiken. (RM.)

Three
THE WINTER COLONY

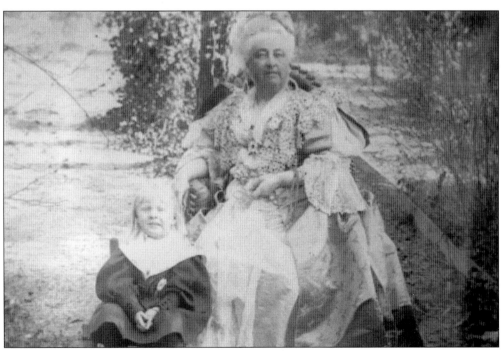

Aiken's evolution into what would become the "Winter Colony" of Northern society began with Celestine Eustis. While in Louisiana, Eustis heard of Aiken and its reputation as a place to rejuvenate one's health. Having taken over guardianship of her brother's children, she came to Aiken in 1872 so that her sickly niece, Louise, could take advantage of the region's reputed restorative powers. This photograph dates from 1877. (The Willcox Hotel.)

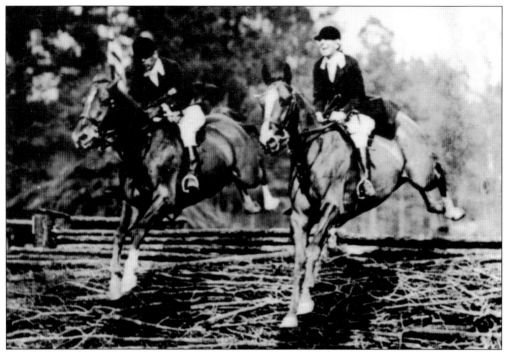

While winters were spent in Aiken, Eustis made sure her niece was introduced to New York Society. Louise met and married prominent Long Island sportsman Thomas Hitchcock, who followed his wife to Aiken for the winter. Hitchcock recognized the area as an ideal place for his horses and began inviting his friends, like William C. Whitney, to join him in Aiken. (Hall of Fame.)

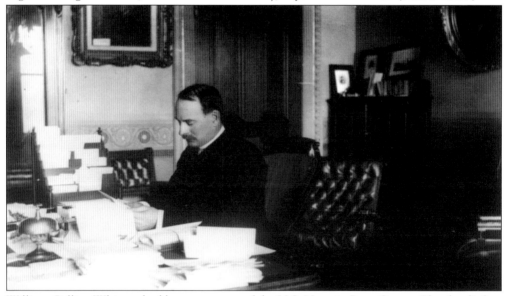

William Collins Whitney had been secretary of the U.S. Navy in Pres. Grover Cleveland's first administration. Also an ardent horseman, he is credited with helping Aiken infrastructure, the polo fields and the race track, in addition to his building his own estate. A New York Society columnist wrote that, "He made it possible to live there because sometimes it was most uncomfortable, without the modern conveniences." (LOC.)

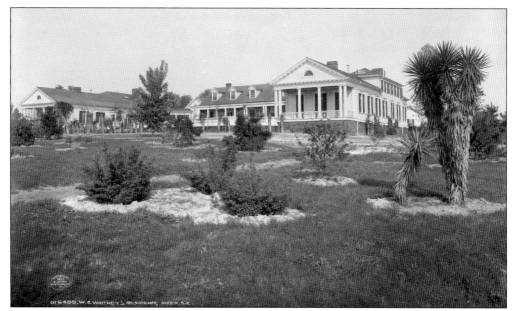

Joye Cottage is one of the oldest and largest of the Winter Colony homes. The original building was a boardinghouse owned by Miss Celestine Eustis before it was purchased, remodeled, and expanded by the newly remarried W. C. Whitney in 1897. Tragically, Edith Whitney broke her neck in a riding accident just five months after the wedding and later died. The 60-room house included four wings and a courtyard. (LOC.)

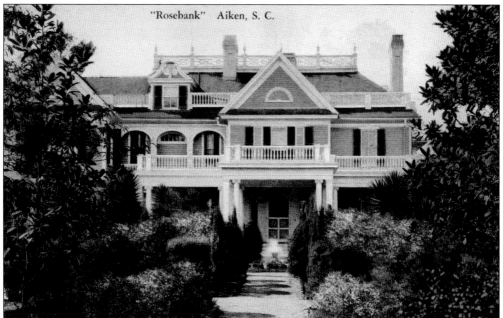

The Winter Colony grew, and so did the need for housing. Homes ranging from small cottages to large mansions were constructed. Many were owned outright by the Winter Colonists, like Rosebank, pictured above, while others were rented for the season. Constructed in 1900 between Colleton and South Boundary Avenues, it was bought by Eugene Grace, who owned Bethlehem Steel. Rosebank had 25 rooms. It was demolished in 1972.

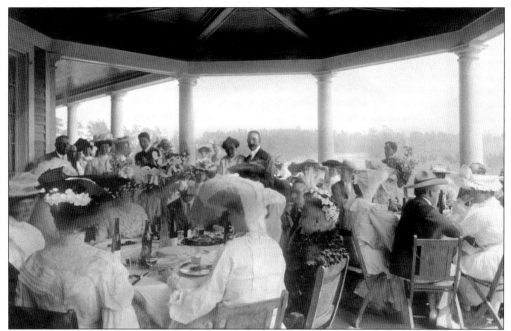

Under the Hitchcocks' stewardship, Aiken transitioned from health resort to winter pleasure resort. They built the Palmetto Club, which was as much a social venue as it was a golf club. Simply referred to as "The Cottage," it was a gathering spot for numerous events. Competitive golfing on Sundays was frowned upon so virtually Sunday afternoon, activities would come to a halt so that everyone could come for tea. (Palmetto.)

The social activities taking place at the cottage would end up the subject of articles in newspapers and magazines up North. The *Metropolitan Magazine* of New York reported that there were often bands at the cottage: "Not a common brass band, played by ordinary musicians, but a concourse of sweet sounds produced by flutes and mandolins in the hands of heiresses and millionaires, who play for love, not money." (Palmetto.)

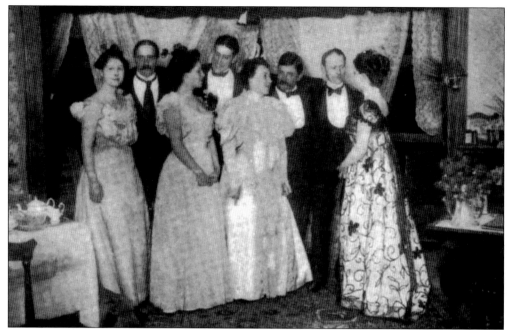

After a day of sport, there was tea to be had and then dinner, followed by bridge. Mrs. John Bohlen of Philadelphia plays host to a group of guests from New York at her Aiken winter cottage in this 1898 photograph. Her son, Charles Bolen, would later marry Celestine "Tina" Eustis, Louise Eustis Hitchcock's niece. (Metropolitan Magazine.)

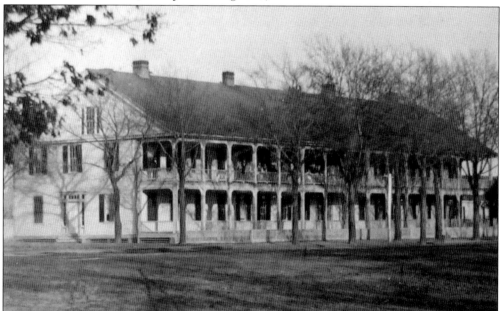

The Park Avenue Hotel, later called the Clarendon, was Aiken's first tourist hotel. The two-story wooden structure was built in the early 1870s to accommodate the Winter Colonists. Located on the north side of Park Avenue between Fairfield and Union Streets, it was located directly across the street from the original passenger station of the SC Railroad. The Clarendon burned in the late 1890s. (Caroliniana.)

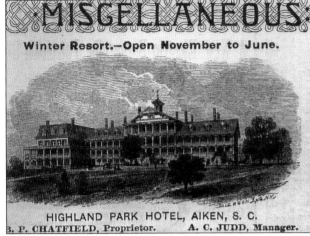

The Highland Park Hotel was Aiken's first grand tourist hotel. The four-story structure was built at a cost of $536,000 between 1869 and 1870 by B. P Chatfield of Connecticut and a group of friends who were convinced that Aiken was a growing health resort. Eventually, Chatfield became the sole owner. The hotel was located on a bluff on 23 acres on Park Avenue's west end, between what is now Highland Park Drive and Hayne Avenue. (ACHM.)

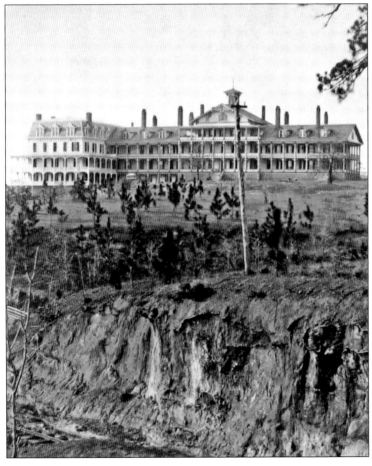

By 1874, a new 100-by-50-foot wing featuring a "French Roof, with Antique Dormer Windows" was added to the hotel to double its capacity to 300 rooms. This photograph shows the South Carolina Railroad Cut in the foreground of the expansive hotel. Truly serving the Winter Colony, it was open only November through June each year. During the off-season, modern amenities would be added, including the means to supply guests with fresh water. (Caroliniana.)

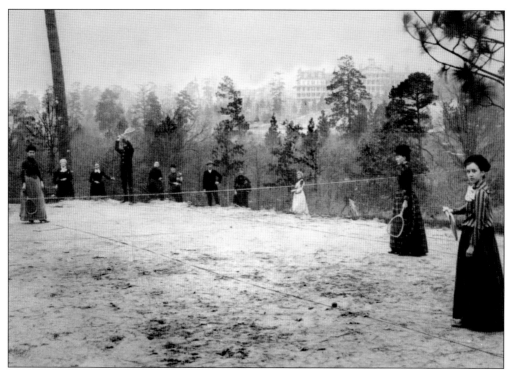

Tennis and badminton were just some of the sports offered to Highland Park guests. Other pastimes included croquet, hiking, and numerous equestrian activities. The hotel advertised a "well-stocked livery stable" for guest use. A 15,000-acre hunting preserve was available nearby to guests. The massive hotel's interior features included a bowling alley as well as men's and ladies' billiard rooms. (Lista.)

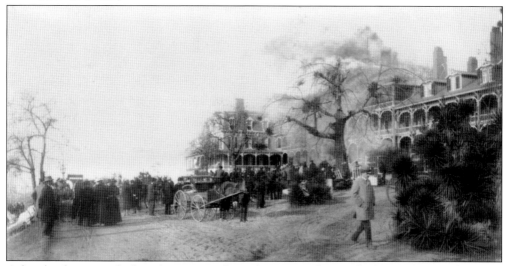

A fire that began in the laundry room in the early morning hours of February 6, 1898, destroyed the Highland Park Hotel. Miraculously, almost all of the 168 guests escaped safely and had enough time to even remove their baggage. The one exception was Thomas Fallon of Boston, who was accidently shot and wounded by a hotel engineer. The hotel was rebuilt in 1914 but was demolished in 1945. (ACHM.)

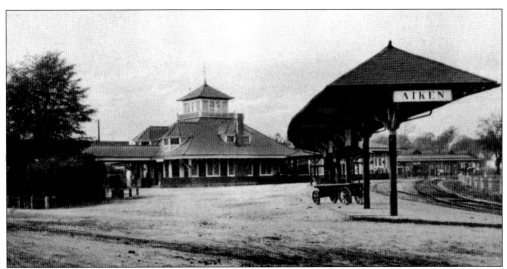

With 22-hour direct rail service now being offered from New York's Penn Station, Aiken built a new railroad station in 1899. Located in the Union Street Parkway at Park Avenue, it replaced a much smaller station that had been located nearby. This building served Aiken for more than 50 years and was used not just as a rail station, but as the center of numerous civic events. (Lista.)

314366 Lobby, Highland Park Hotel, Aiken, S. C. © Underwood & Underwood, N. Y.

After the original Highland Park burned, a new hotel was built in 1914. This structure was designed in a Spanish Colonial Revival style with two towers. Originally, the new Highland Park had just 80 rooms but it was later enlarged to have 125. The hotel was partially burned in 1939 and demolished in 1945. (Caroliniana.)

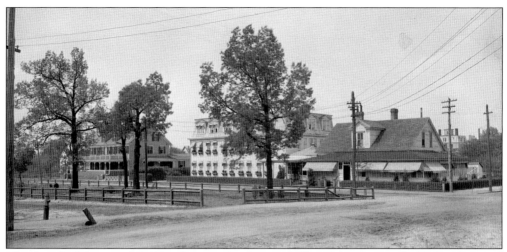

The three buildings in this 1903 photograph taken on Colleton Avenue are the Willcox Inn and Café. The café is the building on the right. A 36-room apartment building on the left was added in 1902 after the Highland Park burned. Originally opened in 1897 by Frederick Willcox, the two main buildings were eventually connected by a structure, which is now part of the present hotel lobby area. (LOC.)

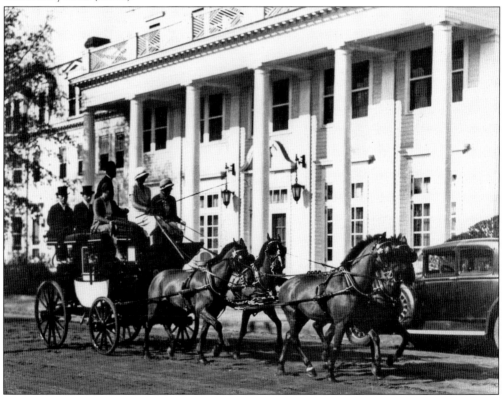

The Willcox was the first choice of accommodations for those who may have previously stayed at the Highland Park. The hotel could boast that it housed Aiken's first bathtub connected to indoor plumbing. Since it backed up to the railroad tracks, it was not unusual for the likes of Franklin D. Roosevelt to come directly to the Willcox by private car. (Lista.)

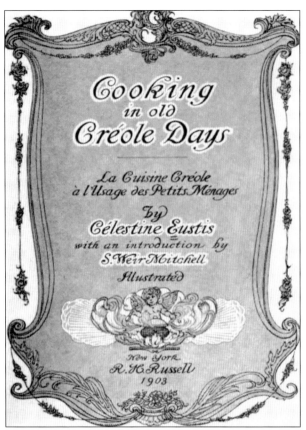

When Celestine Eustis was in her 60s, she added to her celebrity by writing a cookbook that is still in use today. Her 1903 *Cooking in Old Creole Days* reflects her own Creole heritage. Her mother was from a prominent New Orleans family. Acknowledging that many of the recipes came from the servants of her family and friends, she pays tribute by attributing specific recipes to them.

Celestine Eustis is seated almost center in the light-colored attire in a celebration taking place in the piney woods, which had become the center of almost any gathering. This was where golf, hunting, and riding all took place, as did some simple gatherings. Those beckoning others to join them in Aiken proclaimed: "Breathing the perfume of the resin is one of nature's greatest healers." (Hall of Fame.)

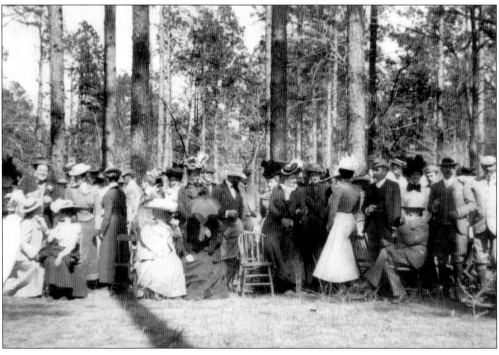

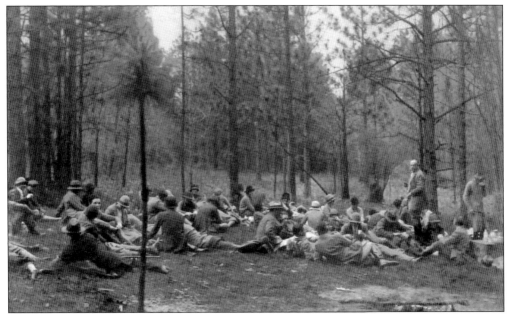

Winter Colonists seemed to shock the folks back North with their behavior in Aiken. The *New York Times* reported that "No one remains indoors. Not a breath of air is wasted." The paper recounted that the men met nearly every other morning at "Tommy" Hitchcock's at the "unfashionable hour" of 5:00 a.m. before going hunting. After lunch, there was golf, tennis, or polo, followed by tea. (Hall of Fame.)

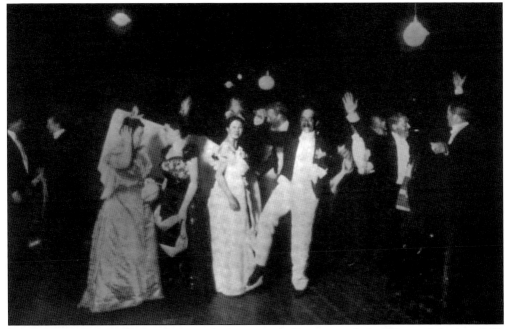

Because days were so filled with sports, bedtime generally came early for Winter Colonists. Still, there were many occasions for evening gaiety. This 1898 photograph shows one of the many dances thrown by the Winter Colonists. The caption from the *Metropolitan Magazine* for which this was taken describe it as a "Barn dance under flashlights." (*Metropolitan Magazine*.)

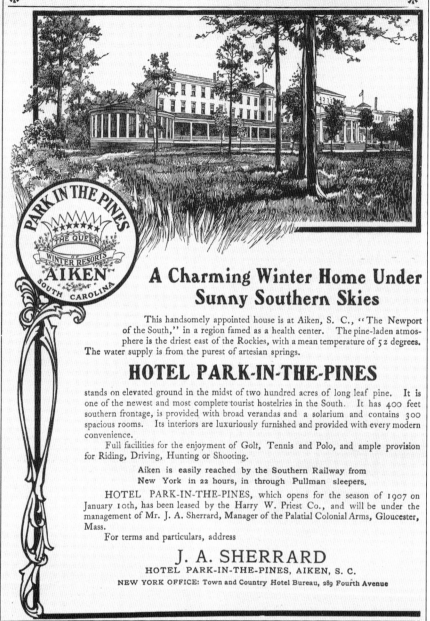

Aiken's second large and stately hotel, the Park in the Pines Hotel, opened around 1900, just a few years after the original Highland Park Hotel burned. The sprawling, three-story hotel was built by a widow from Detroit named Mrs. Julia McArthur for an estimated cost of $300,000. McArthur co-owned the Park Hotel in Mount Clemons, Michigan, along with her aunt, Margretha Kieffer, who wintered in Aiken. Kieffer encouraged McArthur to build in the up-and-coming health resort of Aiken. Nestled on a 40-acre section of Eustis Park, the hotel's advertisements espoused the virtues of the pine trees that surrounded it, saying they had "purifying effects exerted upon the mucous membranes of the nasal passages." At that time, Aiken was being called "the Newport of the South" and was considered *the* health destination in the United States.

Fire erupted in an elevator shaft of the Park in the Pines Hotel around 11 a.m. on February 2, 1913, spreading quickly throughout the three-story wooden structure. The *New York Times* described how guests fled for their lives, leaving jewelry and other valuables behind. Low water pressure was blamed for hampering efforts to save the building. Only the dining room wing was saved, and damage was estimated at $250,000. (LOC.)

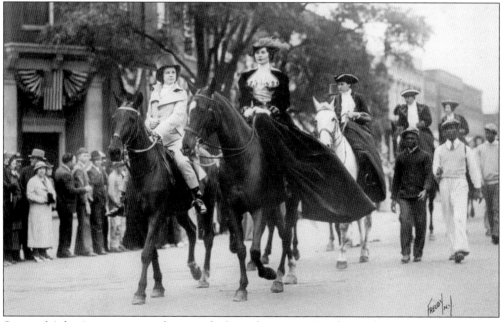

Some of Aiken's most iconic photographs bear the name "Freudy" in the corner. Harry Freudy started his photographic business in the 1920s, traveling with Winter Colonists to Aiken from New York. His sons Ted and Malcom joined the business in the 1940s. The Freudys were well known for photographing equestrian events, but they also photographed debutantes, weddings, christenings, and everyday life. Clients included prominent sportsmen and business and government leaders. (Lista.)

Hopelands was built in the early 1900s by Winter Colonists Charles Oliver Iselin and Hope Goddard Iselin. Aiken County Courthouse records indicate the Iselins purchased the property for $1,650. In addition to overseeing training of their thoroughbred racehorses, they doted on the property itself, planting hundreds of camellias to compliment Hopelands' massive oak trees. (Hall of Fame.)

The Iselins and their daughter Hope are shown here in Hopelands Gardens. The dogs in the photograph are believed to be buried in the property's pet cemetery. In addition to horses, the Iselin's were avid yacht enthusiasts. In the late 1800s, *Time* magazine labeled Charles Iselin as "probably the most famed yachtsman in the U.S." (Hall of Fame.)

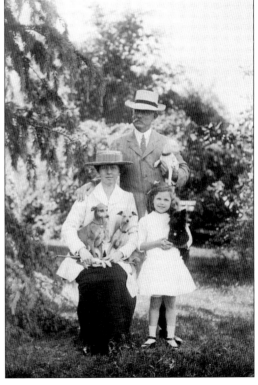

The younger Hope Iselin grew up dividing her time between Aiken and their home in Rhode Island. She shared her parents' love of horses and eventually moved to Tucson, Arizona, in the 1930s. There, she bought a considerable amount of property in Redfield Canyon to allow horses to roam wild on the land. (Hall of Fame.)

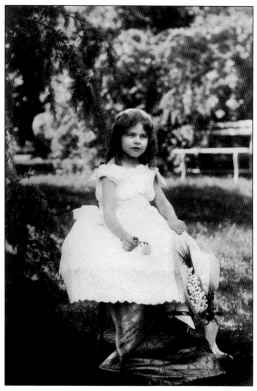

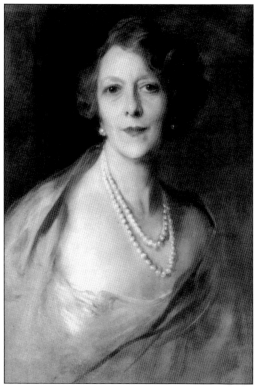

The senior Hope Iselin was an avid sportswoman throughout her life. The first woman to crew in the America's Cup yacht race, she was also an accomplished horsewoman and a close friend of the British royal family. Upon her death in 1970 at the age of 102, Iselin bequeathed Hopelands' 14 acres to the City of Aiken, and it became known as Hopelands Gardens. (Hall of Fame.)

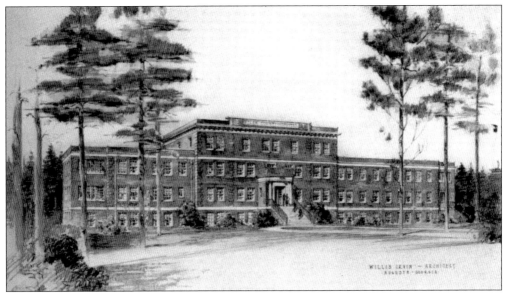

In 1917, Aiken's first hospital, the Aiken Hospital and Relief Society, was built and equipped with money donated by the Iselins. A favorite story has it that Mrs. Iselin won a large amount of money while playing poker and decided to donate it to a local church. The church rejected the "ill-gotten gains," so the Iselins chose instead to help organize the hospital. (ACHM.)

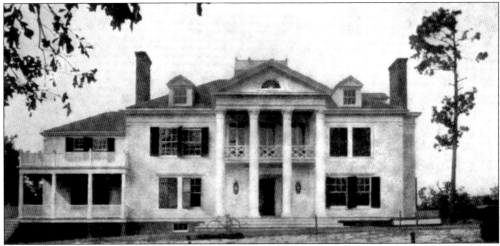

Cincinnati publisher C. M. Hinkle built this "cottage" overlooking Coker Springs in 1898 for $15,000. A member of Palmetto Golf Club's original green committee, Hinkle was an avid golfer and chose the site because of its closeness to the greens. The colonists were known to transport most of their Northern homes' contents, including servants, linens, and silver, to their winter homes via special rail facilities.

The Migration of Society to Aiken

Mrs. J. L. Kernochan

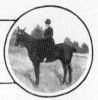
Mrs. Adolf Ladenburg

Mr. W. C. Whitney

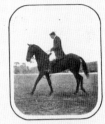
Mr. T. Hitchcock, Jr.

AIKEN has in prospect one of the liveliest seasons it has known in the brief years of its popularity as a fashionable winter resort for the millionaires of the East. The town is not yet over the excitement of its two great sensations—one, the opening of a twenty-thousand-dollar tennis-court by the Aiken Club, and the other the visit of Mr. William C. Whitney's racing string in the splendid stables prepared for its reception. Another event has been the completion of his mile track, which lies nearly two miles beyond his private race-track. Racing is one of Aiken's favorite pastimes, and steeplechasing and polo have ardent champions.

The houses of the Hitchcocks, Eusties, Whitneys, Hunnewells, Motts, Iselins, that of Woodbury Kane, the Mallorys, Harringtons, Sands, Travers, and others stand upon high, sloping lawns that cover a square or more of ground, and are invariably surrounded by high box-hedges. Whiskey Road is the fashionable residence street in Aiken, and is ever alive with teams and horsemen going back and forth to and from the race-tracks, polo-grounds, and golf club.

The Aiken preserves are among the finest in the country. The quail reservation alone occupies 40,000 acres, and is maintained at enormous expense. There are other reservations for deer, fox, rabbits, pigeons, wild doves, and partridges, and these furnish sport for the entire season.

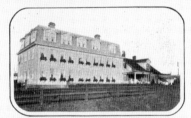
Wilcox's, the Hotel-Club of Aiken

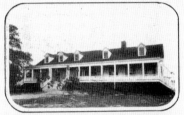
Mr. Whitney's Cottage at Aiken

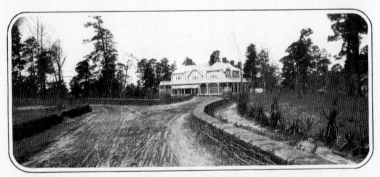
Mr. Clarence Dolan's Cottage at Aiken

Any news about the Winter Colony had universal attraction. Aiken and its Winter Colonists were featured in *Harper's Weekly*'s December 27, 1902, issue. The article detailed the growing number of sporting venues and attempted to explained why the social elite would abandon New York in the winter to head South. The daily activities of the Winter Colonists were monitored closely. The *New York Times* paid particular interest, attempting to keep track of who was leaving from New York for Aiken (and when), as well as printing daily missives as to the town's happenings. Sporting activities were covered in great detail, including scores for polo and shooting matches. *Life Magazine* did a full spread on Aiken in April 1950; in August 1930, *Time Magazine* put Louise Hitchcock on its cover in a feature about polo. (JPT.)

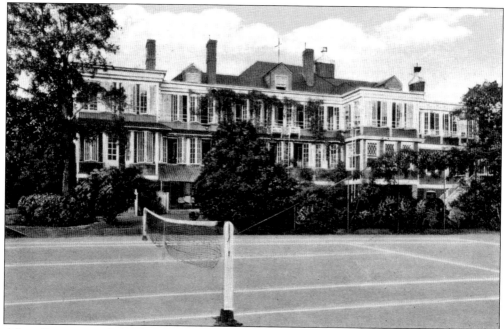

Aiken Preparatory School was founded in 1916 by Louise Hitchcock in an effort to provide education to her youngest son as well as the children of other members of the Winter Colony. The original boarding school was modeled after English public schools. For most of its existence, Aiken Prep was a junior boys boarding school for grades fourth through eight. The cantilevered windows along this side of the building lined a series of porches, which the boys slept on when the weather was warm. The ninth grade was added in 1960. In 1989, through a merger with the Aiken Day School, Aiken Prep became coeducational, serving students kindergarten through 12th grade. It was also listed as the only junior boarding school in the entire Southeastern United States. (Both Aiken Preparatory School.)

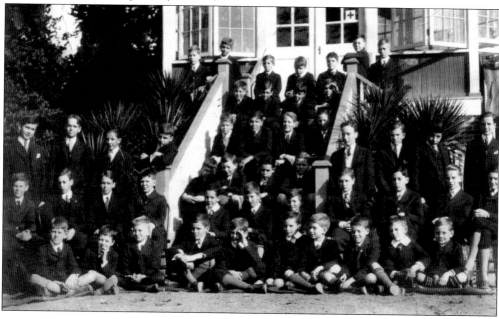

Evelyn Walsh McLean was the last private owner of the Hope Diamond and is shown here wearing it. A part-time resident of Aiken in the 1920s while her sons attended Aiken Preparatory School, Walsh wore the diamond frequently in public. It was reported that she otherwise kept the 45.52 carat blue diamond rolled in a silk stocking in her dresser drawer. (LOC.)

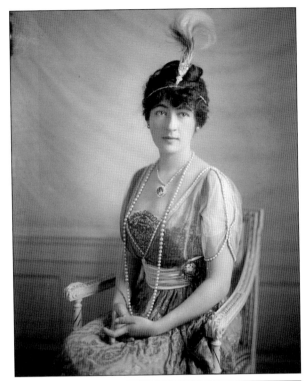

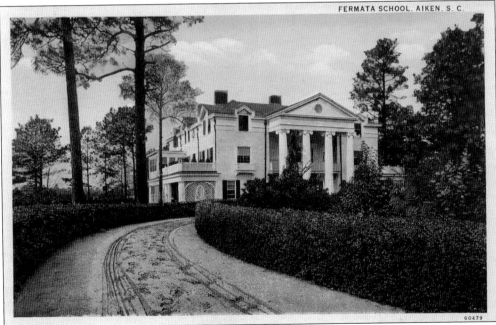

In 1919, Marie Eustis Hofmann founded what became the elite Fermata School for Girls. As wife of internationally recognized pianist Josef Hofmann, she chose the name "Fermata" because it is a musical symbol that calls musicians to hold the note longer than usual. The school's main building was destroyed by fire in 1941. In 1952, a group of local families leased the land and remaining buildings to form a social, swimming, and tennis club.

DANCE

Mr. and Mrs. Astaire married in 1933. She was the former Phyllis Livingston Baker, daughter of Dr. Harold W. Baker, Boston physician and socialite. Mr. Astaire, 41, was born in Omaha, Neb.

FRED ASTAIRE PLOTS OUT NEW ROUTINES AT HIS IN-LAWS' HOME IN AIKEN, S. C.

Many a great performer chooses to live with his profession. Others prefer a life apart. Fred Astaire, who is probably the greatest exponent of America's only important autochthonous dance form, is notable in Hollywood for his absence from that city's social life. Though he owns a home in Beverly Hills, he spends much of each year at Aiken, S. C., where his wife's uncle and aunt, Mr. and Mrs. Henry Worthington Bull, own a large and gracious estate. Here Mr. Astaire plotted routines for his forthcoming picture, *Second Chorus*. Here, a fortnight ago, he reiterated those routines and created some new ones for LIFE's photographer, George Karger.

It is not often that shy, offish Fred Astaire admits a cameraman to his family unit. When working he works hard. When vacationing, he adheres to simple pleasures. Fred Astaire, as these pictures show, is more than an able tap dancer. He is a superb technician who has successfully synthesized the classic attitudes of ballet (note *"temps de poisson"* at upper right, *opposite*) with the footwork and rhythms of pure American buck and wing.

Conceiving new numbers, Astaire often looks back. Here, in an Aiken theater, he sees himself in *Second Chorus*. His film anthology of his own dances runs four hours. Below: he charts a sequence: his feet light rhythmically on proper squares with machine-tool precision.

Freddy Jr., 5, serves as his father's partner when no one bigger is around. He has been dancing since he was 2 years old. "Whenever he hears music," notes Mr. Astaire, "he rattles around a bit."

For more than 20 years, movie star and dancing great Fred Astaire was a regular among the winter colonists. His first wife, Phyllis Potter (nee Phyllis Livingston Baker), was a New York socialite who was accustomed to wintering in Aiken. The couple continued that habit for more than 21 years until her death. This *Life Magazine* article from December 1940 was a rare access by the media into Astaire's private life in Aiken. He enjoyed the anonymity he held in the Southern town. He was a regular at Palmetto Golf Club as well as the Highland Park Golf Club. Residents often spotted him picking up his own mail at the post office and more than one recounted how he danced up the stairs to their delight. The Astaires had two children, Fred Jr. in 1936 and Ava in 1942. Phyllis Astaire passed away of cancer in 1954. (ACHM.)

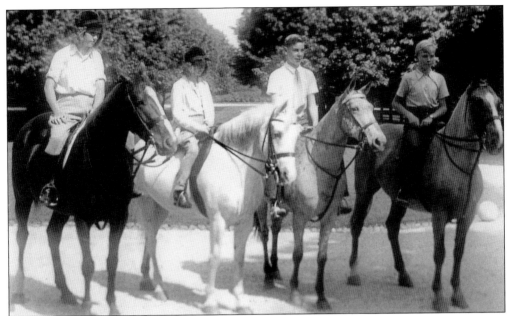

William Whitney died in 1904, but his family continued to occupy Joye Cottage until 1980. This 1940s-era photograph shows two of the Whitney clan on their horses along with their neighbors, Pricilla and Cynthia Howe. The Howe girls were daughters of William Deering Howe and lived across the street in the home known as Banksia. (CAR.)

Cynthia Brooks Howe poses in front of Banksia, which was named after the Lady Banksia roses that grew on the property. The home's origins were that of a wooden Victorian cottage built in 1860. Richard Flint Howe purchased the building and its 3.5 surrounding acres in 1931 and turned the small house into a 32-room mansion, complete with 15 baths and a full-sized ballroom. The brick expansion was designed by architect Willis Irvin. (CAR.)

Richard Flint Howe and his son William Deering Howe are seen relaxing on one of Banksia's porches. The Howes maintained the house until the 1950s. After their departure, Banksia served many uses. During the Savannah River Plant construction, it was a boardinghouse, later becoming the home for the University of South Carolina–Aiken, the Aiken County Library, and finally the Aiken County Historical Museum. (CAR.)

Elsie, the Duchess Torlonia, was only one of the royals who visited Aiken during the early 1900s. The duchess was American-born heiress Mary Elsie Martin before she married Italian prince Don Marino Torlonia, 4th prince of Civitella-Cesi. She is seen here on the grounds of Banksia in the 1930s visiting her friend, Polly Brooks Howe. (CAR.)

The Duke and Duchess of Windsor were frequent visitors to Aiken, arriving to the Winter Colony within months after the scandal in which the duke abdicated his title of King Edward VII. Famously, the abdication on December 10, 1936, was punctuated with his statement that he did so for the twice-divorced American socialite Wallis Warfield Simpson, whom he termed, "the woman I love." (CAR.)

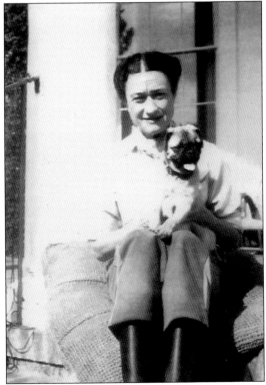

The Duchess of Windsor is pictured on the steps of Richard Howe's home, Banksia, with one of her beloved pugs. She and the duke were close friends of several of the Winter Colonists. Courtney Armour Regan recounts that her parents, Cynthia Brooks Howe Armour and Norman Armour, often traveled throughout Europe with the Windsors. (CAR.)

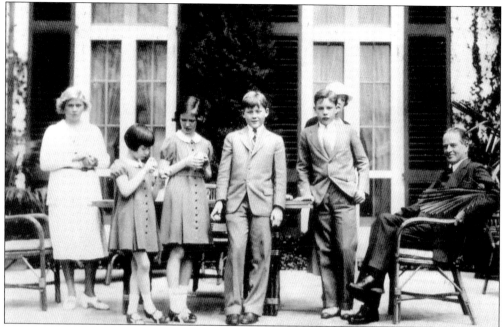

This photograph from the 1930s was taken on the porch of Richard Howe's home. It features, from left to right, Rosemary "Rosie" Warburton, Howe's daughters Pricilla and Cynthia, Barclay "Buzzy" Warburton, an unidentified guest, and Rose and William "Willy" Kissam Vanderbilt II. Willy Vanderbilt was Rosie and Buzzy's stepfather. (CAR.)

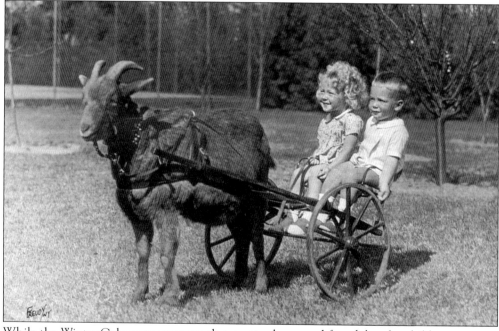

While the Winter Colony was very much a sports playground for adults, the children were not to be forgotten. Every spring, a goat carnival was organized to allow children to drive carts lead by goats. Participants usually included about a dozen carts led by a variety of breeds from Angora to nondescript nannies. (Lista.)

Four
Sport Center of the South

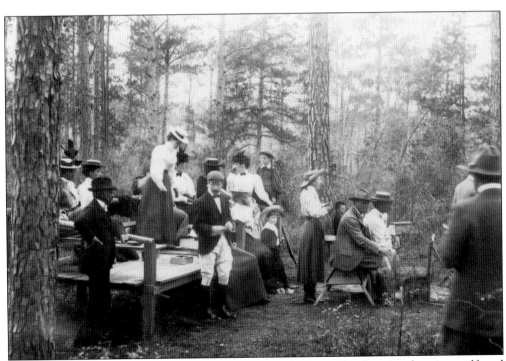

By 1900, the city's penchant for fox hunting, steeple chasing, polo, shooting, hunting, golf, and tennis had gained Aiken a proud new title: "The Sport Center of the South." It was also called "The Queen of Summer Resorts" or "Newport of the South." Much of the pretense of formality was done away with in an atmosphere one article referred to as "healthy and sane." (Caroliniana.)

In 1898, Thomas and Louise Hitchcock and William C. Whitney made the joint purchase of 8,000 acres of pine forest just south of the downtown area. It almost immediately became the center of sporting activities and is now the largest urban forest in the United States. Whitney, the former Secretary of the Navy under Grover Cleveland, had come to Aiken at the invitation of the Hitchcocks.

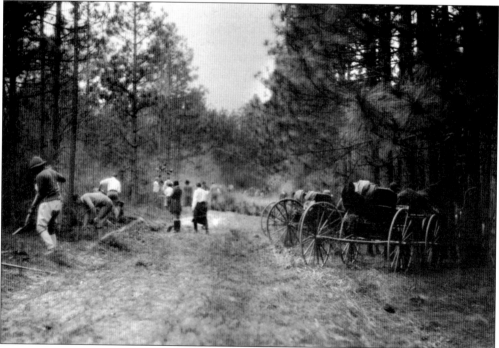

To prepare trails through the forest, the Hitchcocks and Whitneys enlisted friends to participate, forming what became known as the "Axe Club." Community volunteers would work alongside wealthy businessmen in helping to blaze the trails and tend to the woods. All of the jumps erected were made from materials found in the forest. Now largely protected lands, Hitchcock Woods continues to be used for both equestrian and pedestrian purposes. (Hitchcock Woods Foundation.)

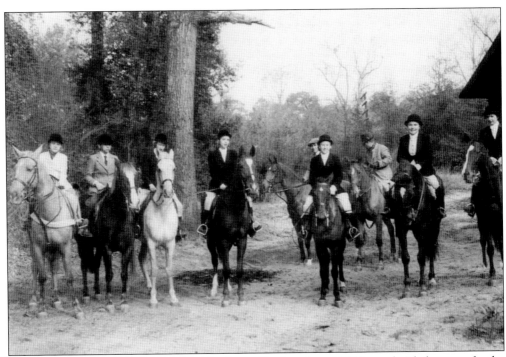

Within three years of the purchase of the forest, Hitchcock and Whitney decided to transfer the property to a board of trustees composed of winter residents of Aiken to be used in perpetuity for sports. In addition to riding trails, the land contained Palmetto Golf Course, two racetracks, and polo fields. The *New York Times* reported their decision in March 1901, listing the property as worth an estimated $100,000. (Hall of Fame.)

Louise Hitchcock was credited by many with the trend for women to ride astride a horse instead of the traditional sidesaddle. The 1901 book *Womanhood* quotes her as saying that riding sidesaddle was dangerous while participating in "mannish" sports, and that she had decided to learn how to mount her horse "man-fashion." The book reported that Hitchcock was not afraid to ride any horse and took "infinite pleasure in training vicious beasts." (ACHM.)

Theodore "Teddy" Roosevelt was just one of the presidents who paid a visit to Palmetto. This photograph is believed to have been prior to his election as vice president in 1900. Several of Roosevelt's family members also spent time in Aiken. His daughter Ethel was visiting Aiken when Roosevelt died in 1919; Nicholas Longworth, Republican speaker of the house and Roosevelt's son-in-law, died of pneumonia in Aiken on April 9, 1931. (Caroliniana.)

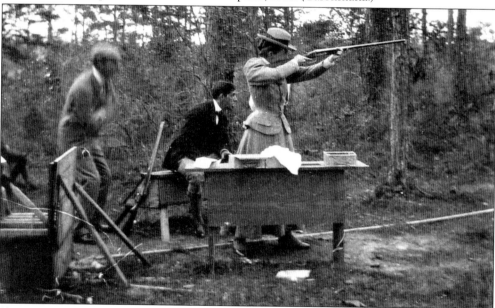

Shooting proved very popular with both men and women. While this photograph features target shooting in Hitchcock Park, the Aiken Gun Club was also available for trap shooting. As many as 10,000 pigeons would be shipped at a time for sport. Northern newspapers reported on shooting tournament results as well as Aiken fashion. "Both men and women dress comfortably and try to forget that they belong to the wealthy class." (Caroliniana.)

The Aiken Hunt was founded in the 1890s by the Hitchcock family and took place in their woods, which were at that time referred to as "Hitchcock Park." The park was stocked regularly with game and, as one article reported in 1902, up to 500 foxes. The foxhunts began informally but quickly proved a sport. The tradition continued each year until World War I, when it was temporarily suspended. (Hall of Fame.)

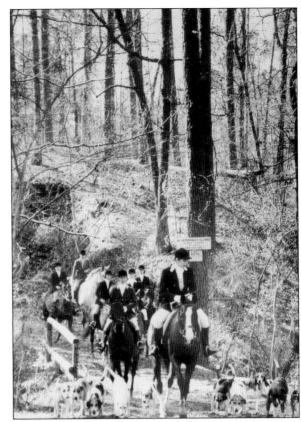

When the Aiken Hunt resumed following the war, the live fox was replaced with a scent in an event that became known as the drag. A bag of aniseed was manually applied to the trails by dragging it across the terrain. It was also dragged outside the fence line to allow horses to get a clean run at the fences. (Hall of Fame.)

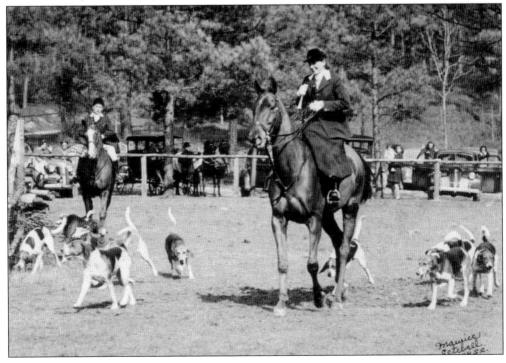

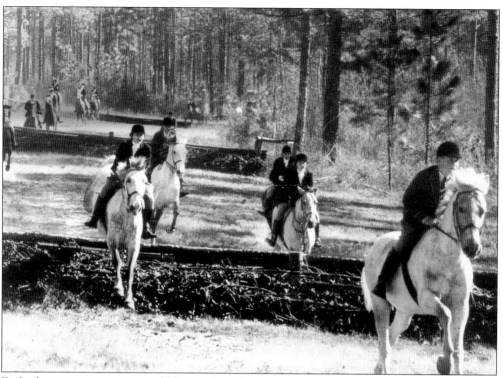

Early drags were run at incredible speeds. The *London Times* described them as "the fastest and most formidable drag in America, with the first flight on steeple chase horses." The fences at the time were 5-feet high and included three panels made of material found in Hitchcock Woods. The course has between 15 and 20 fences. Today's fences rarely exceed 3 feet, 6 inches. (Hall of Fame.)

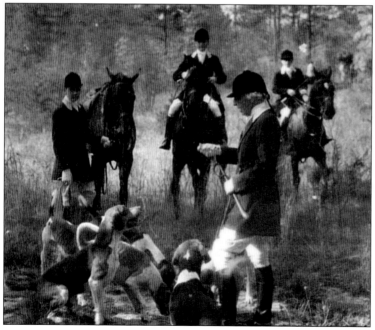

This 1930s photograph shows Louise Hitchcock at the "Kill" or the end of one of the hunts. Tragically, on December 26, 1933, while riding the front line of the children's drag, Louise Hitchcock's horse went down, and she suffered two broken vertebrae in her neck. On April 1, 1934, Mrs. Hitchcock died at her home, Mon Repos, at the age of 70. (Lista.)

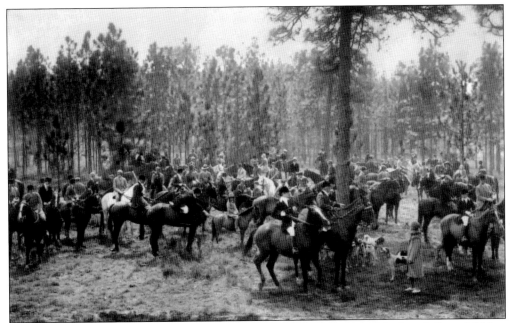

Following Louise Hitchcock's death, her children Thomas "Tommy" Hitchcock Jr. and Helen Hitchcock Clark took steps to preserve the woods their mother had so loved. The Hitchcock Foundation was created in 1939 with an initial 1,191 acres of woodland. Over the years, the charitable organization and its lands grew. In 2006, when the corporate name was charged to The Hitchcock Woods Foundation, acreage stood at a total of 2,100. (Hall of Fame.)

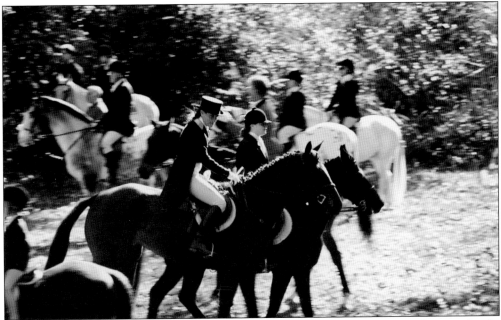

While meets begin in October, by tradition, the Opening Meet and the Blessing of the Hounds take place on Thanksgiving Day. Hunts then take place through March on Tuesdays and Saturdays. The Aiken Hounds are the oldest continuous hunting hounds in the United States and are perpetually ranked in the top club performers by the Masters of the Foxhounds Association. (Lista.)

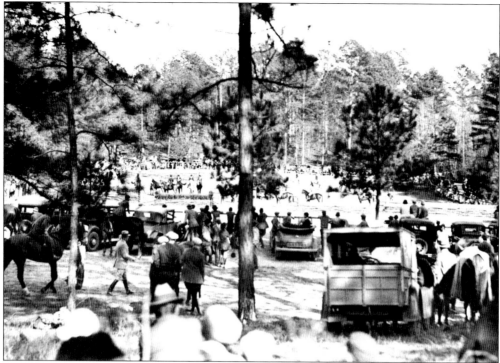

The annual Aiken Horse Show was first started in 1916 by the Hitchcocks. The original show ring was located in the heart of the woods near Barton's Pond, although it later had to be moved to higher ground because of flooding. The Annual Aiken Horse Show is the only time of year that vehicles are allowed into Hitchcock Woods. (Lista.)

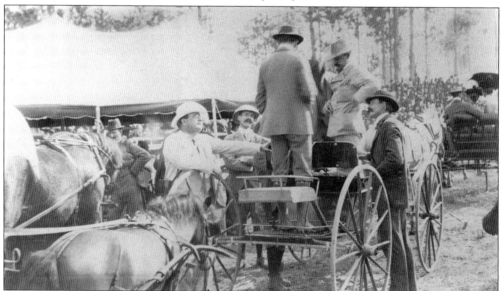

Given the love of horses by the community, the Aiken Horse Show became an instant success. Notice the large crowds on the hill in the distance past the tent. Early competitions were fairly rustic. The contemporary Aiken Horse Show is held for three days and is considered one of the most elegant equestrian events in Aiken. (Palmetto.)

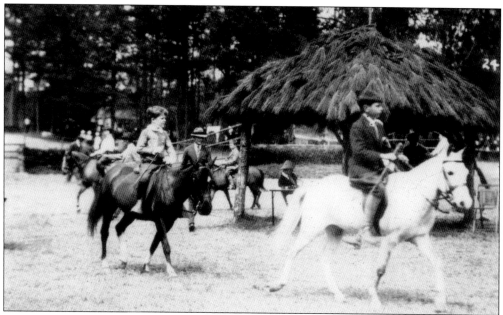

Far from being an event for the adults, the Aiken Horse Show from the beginning featured events for youngsters. The show was seen as a way to introduce children to equestrian life, and there were years where an entire day was devoted to the "children of the cottage colony," as they were often called. Until her death, Louise Hitchcock awarded the ribbons to youngsters displaying their saddle skills. (Hall of Fame.)

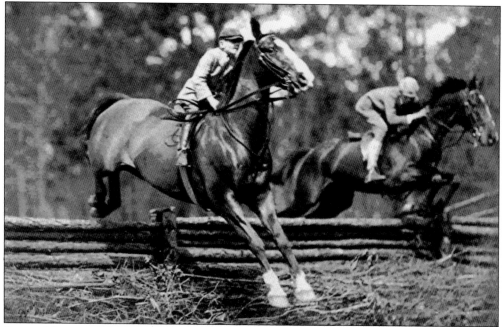

Some of the nation's best riders and polo players experienced their first competitions at the Aiken Horse Show. The young boy in the foreground of this photograph is Pete Bostwick. Here he is about 10 years old, but Bostwick would one day become one of the most recognized names in steeplechase training and a member of the National Racing Hall of Fame. (Hall of Fame.)

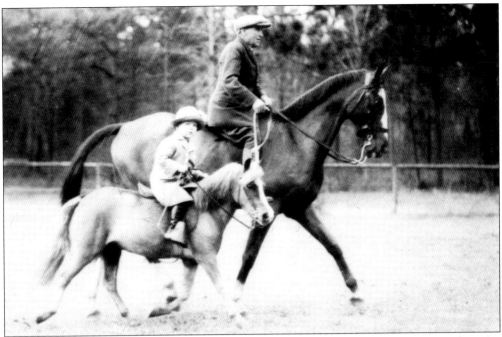

This photograph is an example of the self-assurance of even the youngest riders attending the Aiken Horse Show. Riding confidently next to an adult, he is attired as any other serious horseman would be. In today's show, youngsters under the age of seven are allowed to participate only in the Lead-line Class, where they ride a horse while an adult leads it. (Hall of Fame.)

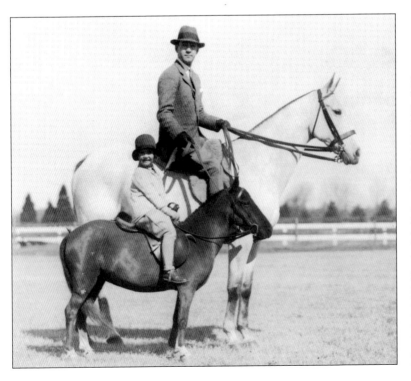

Banksia owner William Deering Howe is shown here at the Aiken Horse Show with his daughter Cynthia Brooks Howe in the early 1930s. William Howe is on his Irish Hunter, which he referred to as his "old grey mare." A noted horseman, Howe also owned the celebrated Highpool's Stables in Brookville, New York. (CAR.)

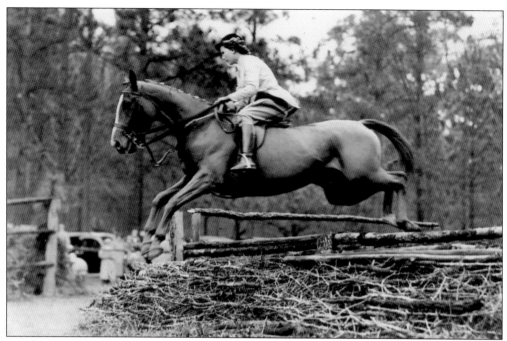

Cynthia Brooks Howe was about 14 years old when she competed in the Aiken Horse Show on her horse Bubbles. One of the Howe family rules was that Cynthia and her sister, Pricilla, could name each other's horse. While Cynthia chose a more traditional name for her sister's horse, Pricilla dubbed Cynthia's horse "Bubbles," and the name remained. (CAR.)

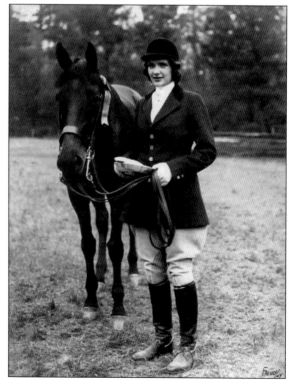

Dolly Von Stade Bostwick was as active in the horse community as her polo champion husband, Pete Bostwick. She grew up in Long Island as an avid rider, and her father, F. Skiddy Von Stade was a champion polo player in the early days of the game. Mrs. Bostwick was a Master of the Aiken Hounds whose kennels now bear her name. The Aiken Horse Show yearly awards the Dolly Von Stade Bostwick Sportsmanship Trophy. (Hall of Fame.)

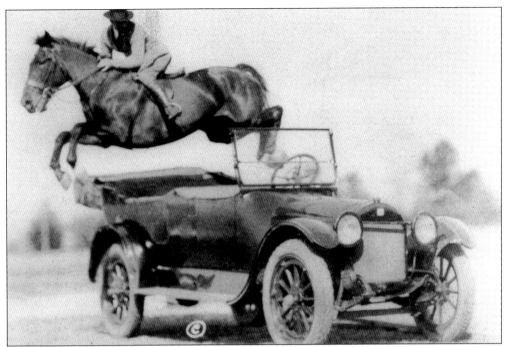

While these sorts of theatrics were not part of the Horse Show competition, it no doubt shows the jumping skills of some of the thoroughbreds of Aiken. The origins of this photograph are not known, but it was donated appropriately enough to the Aiken Thoroughbred Racing Hall of Fame and Museum. (Hall of Fame.)

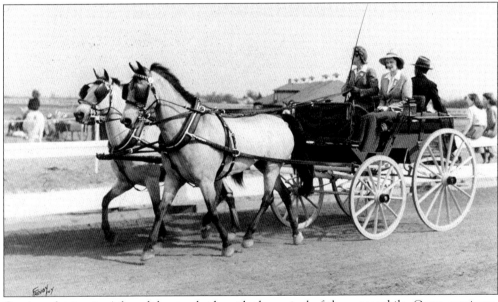

Carriage driving in Aiken did not subside with the arrival of the automobile. Carts, carriages, and their drivers have been present at just about every equestrian event in Aiken since the 1800s. For many, motorized modes of transportation simply could not replace the carriage's elegance. The Aiken Driving Club was formed in 1987 to ensure that the tradition continues. Many of the carriages driven today date to those early times. (Hall of Fame.)

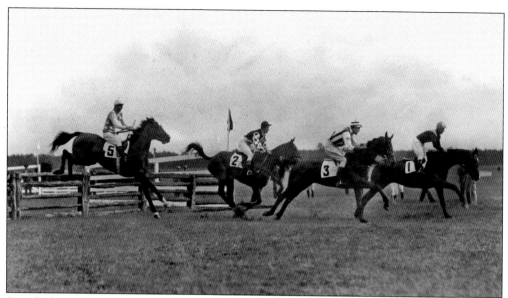

Steeplechase got its foothold in Aiken when the Hitchcocks built a steeplechase training facility on their property in the early 1900s and began training weanlings imported from England. Thomas Hitchcock helped found the Aiken Steeplechase Association in 1930. The first official race was run in Hitchcock Woods along the Aiken Hounds draglines. Over a thousand people from as far away as Camden, South Carolina, came to watch. (Caroliniana.)

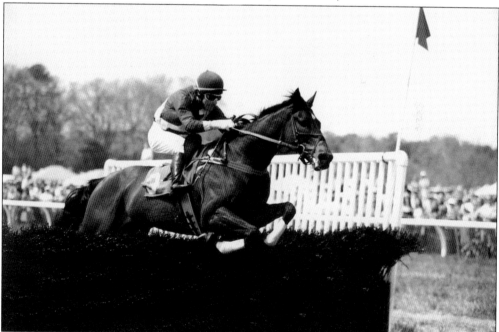

Aiken is the home to many steeplechase legends, including Thomas Hitchcock, considered the Dean of American Steeplechase, and Ambrose Clark, considered one of the sport's greatest. Still, steeplechase was halted in Aiken for 25 years because of war and other issues. Resuming in 1967, the city now plays host to the Imperial Cup each March and the Holiday Cup in October. Both races are sanctioned by the National Steeplechase Association. (Lista.)

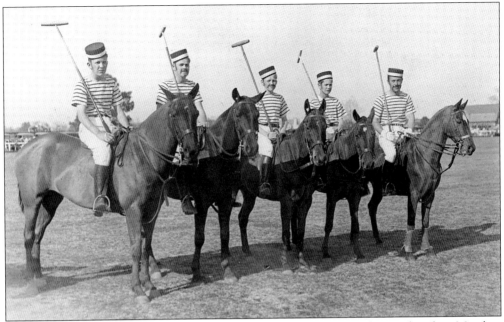

Playing Polo in Aiken

GAY TIMES AT THE NEWPORT OF SOUTH CAROLINA

Crowded Hotels and Boarding Houses—The Introduction of James Gordon Bennett's Favorite Sport—Names of the Players—Society Gossip.

(From an Occasional Correspondent)

Aiken, March 23, 1882. Aiken is in her glory. The season is at its height. The Highland Park and Park Avenue Hotels are crowded with Northern visitors. All the smaller hotels and private boarding houses are testing their capacity. Gay parties of ladies and gentlemen mounted on prancing steeds dash over the country enjoying the delightful surroundings, through the beautiful driveways and bridle paths of our celebrated pine forest. Picnic parties have been the order of the day, and sumptuous lunches have been served that would do honor to Delmonico's table. Those of a military taste have been entertained with street and dress parades of the crack military company of this city, the Palmetto Rifles, fairs in aid of the churches novel and entertaining concerts by the colored Sunday School, etc, etc. But the great event of the season has been the brilliant and successful introduction of James Gordon Bennett's popular and national game, Polo. It has caused a great sensation, and completely revolutionized the city, as far as amusements are concerned. Speaking of Mr. Bennett it was very proper that the game should be first introduced by a New Yorker, Capt. C. S. Wallace, for years connected with the great sugar house of Havemeyer & Co. Yet there is no more enthusiastic or able player than the honorable mayor of the City, Mayor Davis.

Among the prominent gentlemen who participated should be mentioned also Capt. R. B. Barber, Englewood, N. J., Mr. Peterkin of the Manhattan Club, Mr. W. R. Lincoln well known in social circles in Baltimore, Edward Tuttle, of Boston, and Mr. Curtis, of Aiken. Contests thus far have been very exciting and witnessed by the entire population and visitors in the city, every available horse and carriage being pressed into service by friends of the "Reds and the Blues." The scene reminding one vividly of festive days and the excitement attending an English race-course or an Oxford and Cambridge boat race in the suburbs of "Old London," where the crowds wear the colors of their favorites and present the victors with rare gifts at the close. But space will not permit more other than to say that the merchants sent a committee with an urgent invitation which has been accepted to participate in the grand parada and festivities of the second day of the Schutzenfest to be held here in April, when the Governor and a large number of military societies and gentlemen from South Carolina, Georgia and elsewhere will be present.

Miss Eustis, granddaughter of Hon. W. W. Corcoran, of Washington, D. C., entertained her many friends yesterday in a royal manner at the springs and park near Barton's Pond."

Aiken's first polo match was played on March 23, 1882, only six years after the first U.S. match was played at New York's Dickel's Riding Academy at Thirty-ninth Street and Fifth Avenue. This photograph from 1932 was taken during the 50th anniversary celebration of that event. Organized by Capt. Clarence Southerland Wallace, a New Yorker and an executive of the Havemeyer Sugar Company, the games took place on fields still used by today's polo matches. (Hall of Fame.)

This article from Charleston's *News and Courier Newspaper* recounts the events of that first momentous match. It refers to polo as "James Gordon Bennett's Favorite Sport." Bennett was the publisher of the *New York Herald* and became attracted to polo while working in Paris. It was reported that the entire city of Aiken and its visitors turned out for the first matches, which were gala events complete with parades and picnics. (Hall of Fame.)

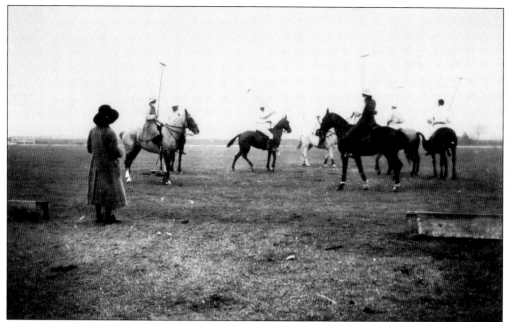

This photograph from Eleanor Phelps Wilds' personal album shows the start of the first period of a polo match in 1911. The daughter of noted Winter Colonist Sheffield Phelps, Mrs. Wilds grew up as one of the "cottage children." She married Aiken doctor Richard Wilds in 1923 and later founded the Aiken County Hospital Auxiliary. (Caroliniana.)

Eleanor Phelps Wilds took numerous photographs of polo matches, as evidenced by her albums. Here, Sophie Mott is seen keeping a close eye on the 1911 match. Mott was also a Winter Colony regular and the daughter of well-known surgeon, Dr. Valentine Mott. Dr. Mott served on the first Green Committee for the Palmetto Club. (Caroliniana.)

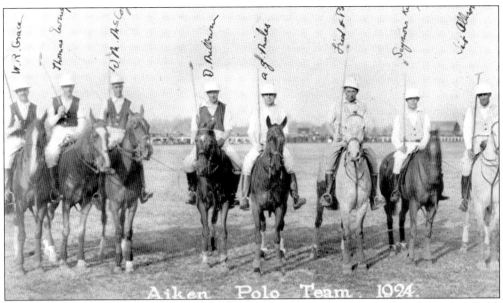

This photograph of the 1924 Aiken Polo Team was take prior to a match at Whitney Field. From left to right, the team members seen here are W. R. Grace, Thomas Ewing, W. M. McCoy, Devereaux Millburn, A. Graham Miles, Fred H. Post, Seymour Knox, and Richard Allison. A ten-goaler, Millburn was considered a pioneer of the game and was featured on the cover of *Time* magazine in 1927. (Hall of Fame.)

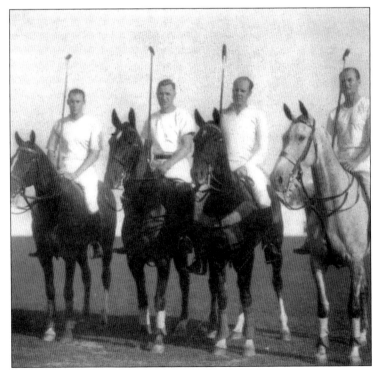

Thomas Hitchcock Jr. captained the American International Team in 1930 as they competed in the Westchester Cup. The Americans proved victorious, beating England 10-5 in the first match and 14-9 in the second. The *London Times* wrote "Captain Hitchcock was everywhere. The Britons could not send the ball away from him." Seen here from left to right are W. F. C. Guest, Thomas Hitchcock Jr., E. A. S. Hopping, and Eric Pedley. (ACHM.)

In 1932, Aiken marked the 50th anniversary of its first polo match with a huge celebration. The match was preceded by a parade through the center of Aiken led by the polo players and featuring more than 75 festooned carriages, buckboards, and surreys. Participants were decked out in period costume with many of the men sporting paper mustaches and beards. Even South Carolina governor I. C. Blackwood took part in the merriment, as did the University of South Carolina 40-piece brass band. The parade formed on Highland Park, proceeded down Park Avenue to York Street, and then over to Whitney Fields via South Boundary Avenue. The *Aiken Standard* reported, "The members of the Winter Colony have been particularly enthusiastic over the semi-centennial celebration and have gone through great pains to provide themselves with fitting costumes for the celebration." (Both Hall of Fame.)

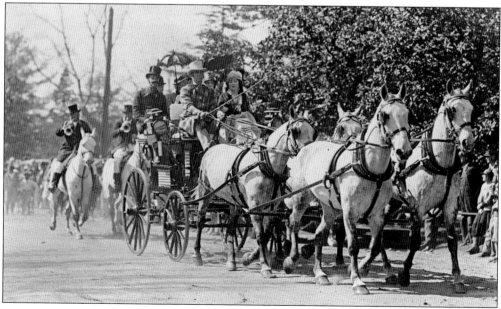

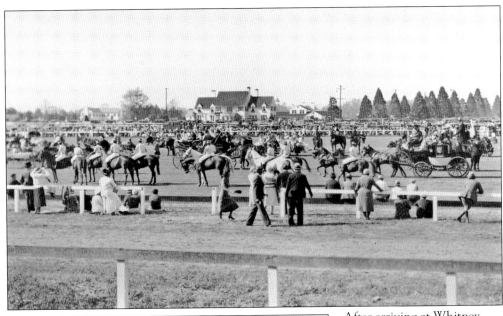

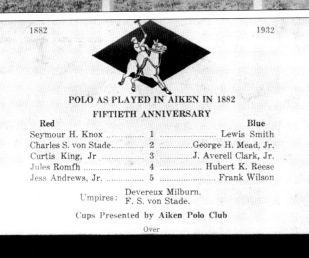

After arriving at Whitney Field, the parade continued to allow those who had gathered there to enjoy the pageantry. Prizes were awarded to the "best of" in several categories for the parade. Judges included Louise Hitchcock, Mrs. H. E. Talbot, Mrs. Frank P. Henderson, and Schuyler Parsons. An estimated 10,000 spectators crowded Whitney Field to be part of the celebration. (Hall of Fame.)

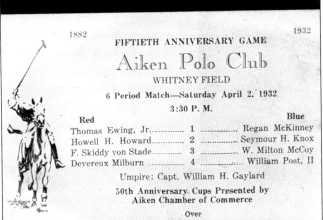

This card depicts the lineup of the two matches marking the 50th anniversary of polo in Aiken. All of the players in the first match were boys from Aiken Preparatory School, with the exception of Seymour Knox and Lewis Smith. Umpires F. Skiddy Von Stade and Devereux Milburn were both former top polo players and played in the regular match. (Hall of Fame.)

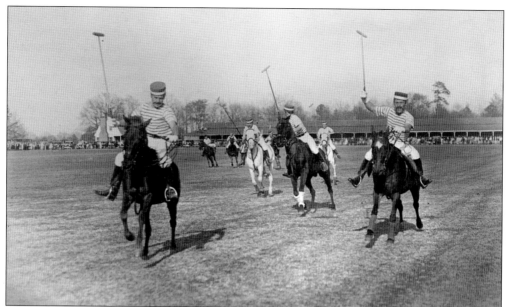

The teams for the anniversary matches were divided into red and blue, with all the players wearing costumes used by polo players from 1882—including high top hats. In the "regular" match of the day, the Blue team proved to be the victors, winning six to three. Billy Post was the top scorer with three goals. (Hall of Fame.)

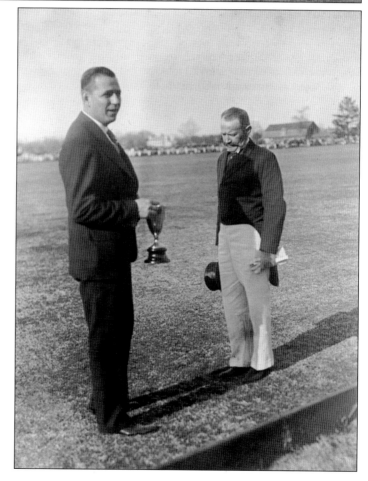

A. H. Ward of the Aiken Chamber of Commerce presented a gold cup to the Aiken Polo Club at the end of the festivities and congratulated the organization on achieving its 50-year milestone. Club secretary George H. Mead accepted the trophy and referred to Aiken as "the union of North and South." (Hall of Fame.)

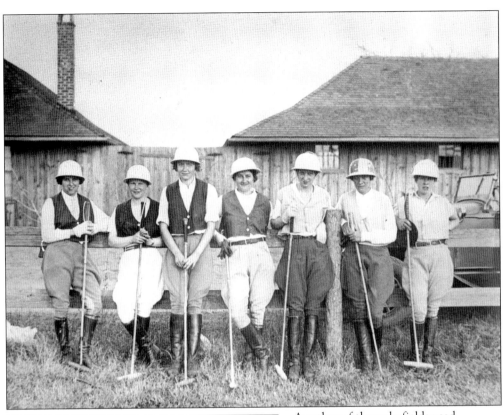

Another of the polo fields used regularly in Aiken was the Meadow Lark Field. It is now the sand ring next to the Whitney Polo Field. From left to right, the seven women in this photograph are Molly Crawford, Anne Schley, Francis Post, Louise Richardson, Euna Crawford, Josepha Hoffman, and Margaret Flick. The *New York Times* acknowledged that Aiken women play polo at the same level as the men. (Lista.)

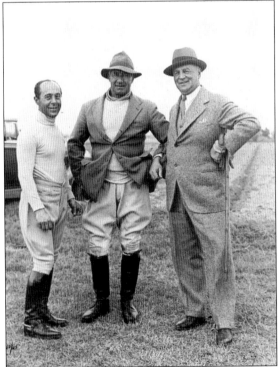

Three nationally known polo players pose after a match at Whitney Field in 1937. Seen here from left to right are Seymour Knox II, a 7-goal player; Devereux Milburn Jr., a 10-goal player; and Louis E. Stoddard, a 10-goal player. Stoddard had recently given up his seat as chairman of the U.S. Polo Association. Aiken is the only polo community in the United States to have had four chairmen. (Hall of Fame.)

This 1937 photograph shows H. G. "Pete" Bostwick (right) next to Arthur Borden in a tongue-in-cheek picture labeled "The Long and Short of Polo." Bostwick was an eight-goal player who gained fame as a steeplechase jockey, horse trainer, and court-tennis player. Borden was a vice president of the American Polo Association and was well known for his indoor polo abilities. (Hall of Fame.)

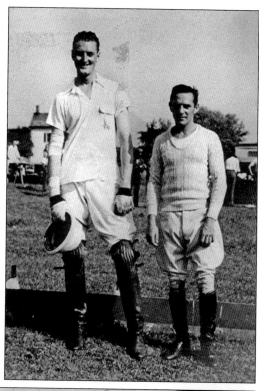

In 1938, Devereux Millburn (left) was presented the Howell Howard Cup after a match by Aiken Polo Club president Seymour Knox. The cup was named in honor of Howell, who had been a well-respected fellow polo player. In 1937, he was fatally injured during a match at the Meadow Brook Hunt Club in Westbury, New York, when his pony fell. (Hall of Fame.)

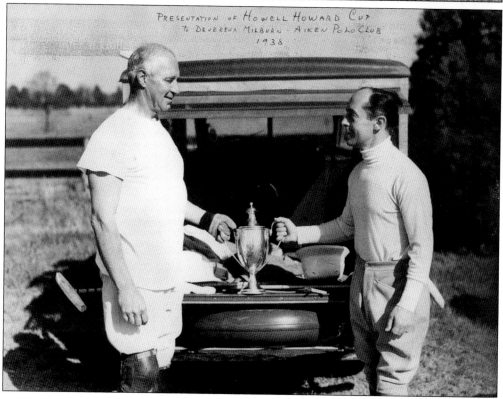

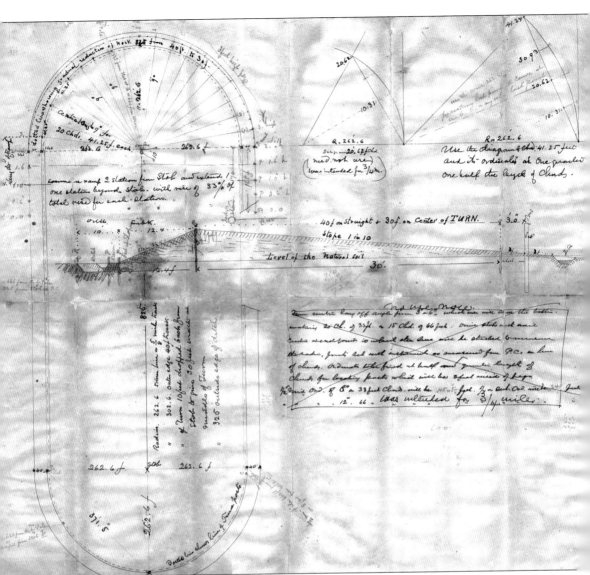

These are the original blueprints for the Whitney Track, located at Whitney Field next to the polo fields. Also known as "The Little Track," the three-quarter-mile track and its surrounding buildings were designed by Jason V. George Sr. George had worked on the additions to Joye Cottage when it was purchased by W. C. Whitney and is believed to have been hired at that time to design the racetrack. A contractor and builder, Mr. George worked in Aiken from the late 1800s until his death in 1905. He is also responsible for the building of the original Willcox Hotel, Rye Patch, and the new clubhouse at the Palmetto Golf Course. The clubhouse was the last project he completed before he died. Well respected in the community, George was an Aiken city council member from 1901 to 1902 and served as mayor pro tem. (Hall of Fame.)

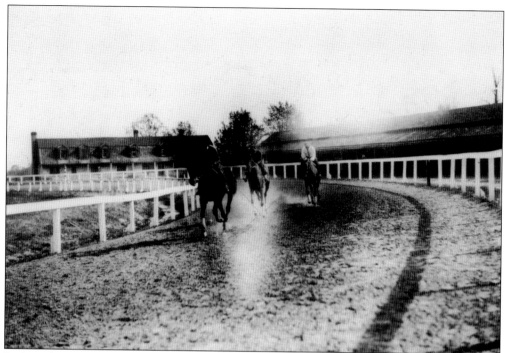

Built in late 1898, the Whitney Track was the first racetrack built in Aiken. W. C. Whitney's love for horses was legendary, and he had been anxious to bring the sport of racing to his new Southern home. Race meets occurred regularly during the season. By 1902, he had doubled the size of his stables to make room for up to 60 horses. (Hall of Fame.)

Francis Post and her Argentinean fiancé, Ricardo Santamarina, were in Aiken for a series of engagement parties when this 1939 photograph was taken. Post was the daughter of one of Aiken's first polo trainers, Fred Post. The couple bred polo ponies and became famous for the Santamarina grays. Her contributions to polo are noted with the Francis Post Santamarina polo series, held to help preserve the historic Winthrop Field. (Hall of Fame.)

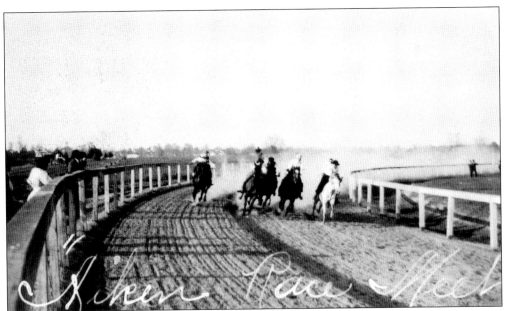

The year 1907 saw the beginning of a new Aiken equestrian tradition called the Aiken Race Meet, which would later be called the Aiken Trials. Held at Whitney Polo field, there were several phases of competition. Two-year-old thoroughbreds would run five quarter-mile sprints, which would be the first time these horses had competed under actual racing conditions. There were four trophied events in which three-year-olds would race. (Caroliniana.)

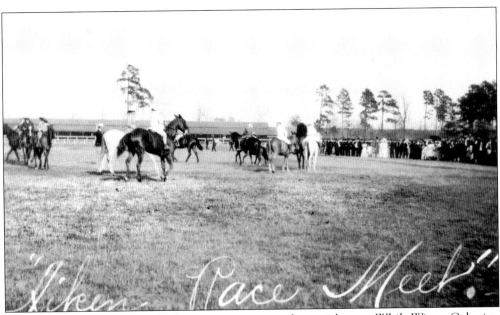

Held the second week in March, the races were very much a social event. While Winter Colonists were known for not dressing up on a regular basis, the race meets saw people turn out in their finest. The stables at Whitney Field can be seen in the background as the horses parade for the spectators. Winners in each division received ribbons and trophies rather than monetary prizes. (Caroliniana.)

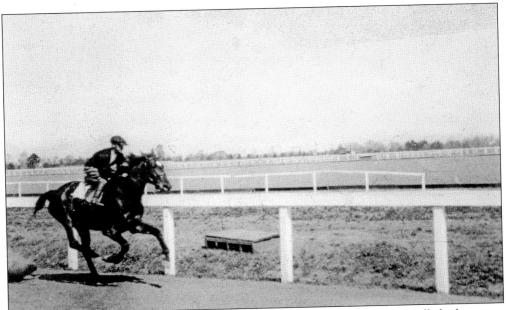

The Aiken Training Track was constructed in 1941 by Fred H. Post, who initially had come to Aiken with his son William to play polo. Finding ideal conditions for training his flat racers, he bought land and constructed the track. It did not take long for the track to gain a reputation as being one of the finest training centers in the United States. (Hall of Fame.)

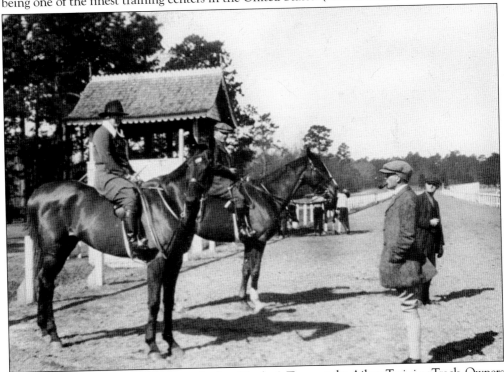

The tower in back of the two riders is the first Clocker's Tower at the Aiken Training Track. Owners and trainers would stand in the tower and clock the horses for their speed as they came down the track. This photograph dates to about 1941, just after the track was opened. (Hall of Fame.)

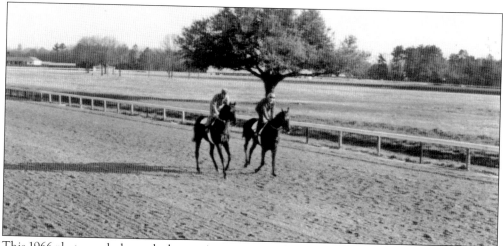

This 1966 photograph shows the horses Assagai and Daily Reminder going through their exercises at the Aiken Training Track. The tree behind them is known as "Blue Peter's Tree." Blue Peter was a 1948 two-year old national champion thoroughbred and a member of the Aiken Thoroughbred Hall of Fame. Blue Peter died of an illness at the age of four and is interred beneath the tree. (Hall of Fame.)

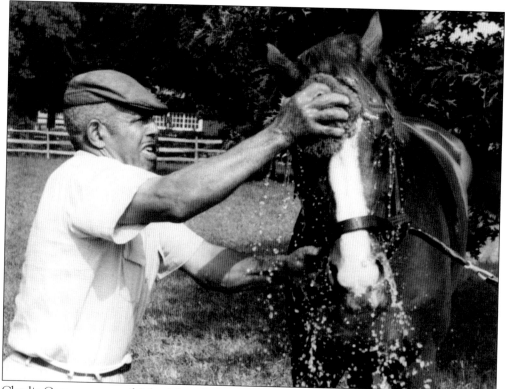

Charlie Carter was one of Aiken's best-known horse groomsmen. Carter worked with Greentree and Gable Stables and was responsible for prepping the horses for their races. The stables' owners thought so much of his abilities that they traveled him to the races, a practice that was not the norm. Carter helped groom horses for races at such notable tracks as Belmont and Aqueduct. (Hall of Fame.)

These two photographs from the early 1900s portray two Aiken jockeys. While their names are unknown, the pictures themselves speak to their success, or at the very least these men's reputations with the owners of the horses for which they raced. Not every jockey would be afforded this sort of recognition as to have their photograph taken for posterity. In the late 1800s to early 1900s, there were many black jockeys in the field of horse racing. Jimmy "Wink" Winkfield dominated the field and won the Kentucky Derby in 1901 and 1902. He was the last black Kentucky Derby winner. Winkfield won more than 2,600 races in his career, eventually moving to Aiken for a time to work as a trainer. (Both Hall of Fame.)

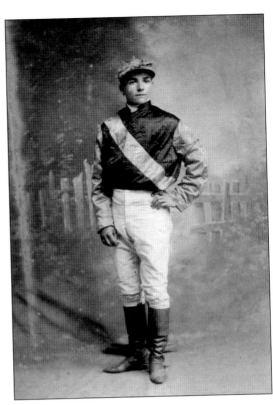

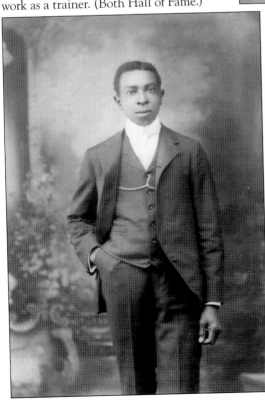

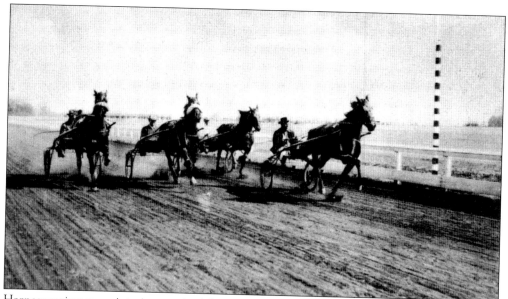

Harness racing came into its own in Aiken in 1936 when Dunbar Bostwick decided to build a complex to focus on his interest in training standardbred horses (pacers and trotters). The mile track helped earn Aiken a reputation as a standardbred training center. Bostwick's commitment to the sport of harness racing eventually earned him a spot in the Harness Racing Hall of Fame. (Hall of Fame.)

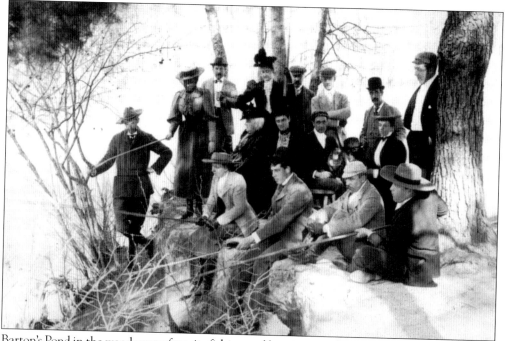

Barton's Pond in the woods was a favorite fishing and boating spot for Aiken's sporting community in the 1890s. This picture shows Thomas and Louise Hitchcock seated on the bank with poles, while Celestine Eustis is in the plumed hat behind them. Standing with the pole to the left is patron-of-the-arts Isabella Stewart Gardner. Others pictured include members of the Appleton family of Boston. (Lista.)

Now outlawed, the blood sport of cockfighting was a popular gambling event in Aiken for over a century. The events pitted two bred roosters against each other in a battle to the death. Aiken was known for "main" rivalries—events featuring at least seven individual fights—between North and South Carolina birds. The University of South Carolina has used the fighting Gamecock as their mascot since 1900. (Caroliniana.)

Before leaving for New York in January 1902, W. C. Whitney gave orders for a new squash court to be erected on Easy Street across from his residence at Joye Cottage. The Whitney Squash Court was constructed in a prairie style and contained four squash courts. Other outbuildings on the 5-acre property included the Whitney Stables, a greenhouse, a laundry, and two small one-story frame houses. (Caroliniana.)

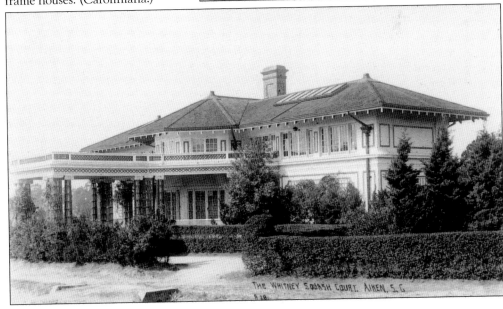

The Aiken Club was incorporated in 1898 as an exclusive club for the men of the Winter Colony. They originally met in a small cottage before expanding in 1902 to include this court tennis building on Newberry Street. The two-story brick structure was constructed under financing by William C. Whitney, who was behind the original organization of the club. The Aiken Club complex originally included stables, a squash court, and servant's quarters, as well as the tennis court. Court tennis originated in France more than 700 years ago and uses the walls and ceilings during the matches. The internationally recognized Aiken Tennis Club remains one of the few places in the United States where one can play court or "real tennis." It has played host to several world championships. (Both RM.)

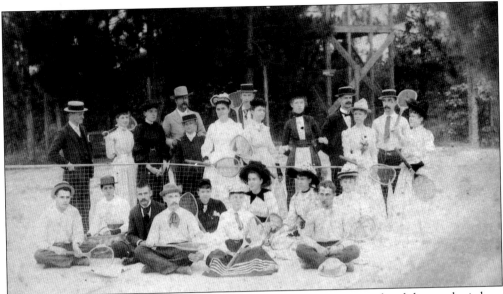
The game of lawn tennis originated in England in the mid-1800s, and it did not take it long to make it "across the pond" to New York. It quickly proved popular with the New York social set, who then shipped it south to Aiken. This 1887 photograph shows some of Aiken's earliest players. (Caroliniana.)

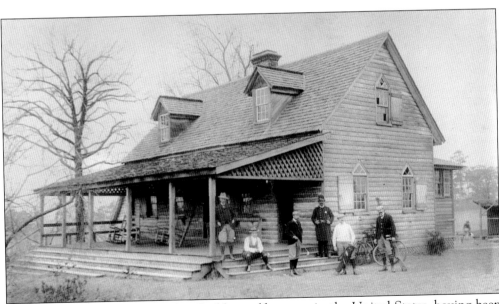
Palmetto Golf Club is one of the 10 oldest golf courses in the United States, having been founded in Thomas Hitchcock. The course was—and is—located south of the downtown area. It began with just four holes, laid out where the present 16th, 17th, and 18th holes are now located. (Palmetto.)

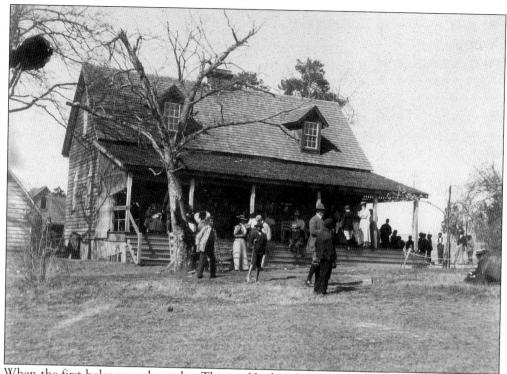

When the first holes proved popular, Thomas Hitchcock Sr. purchased a piece of neighboring land from W. C. Tibbets to expand and construct an additional five holes. The land included an old farmhouse, which soon became the course's first clubhouse. It also quickly proved to be a popular gathering place for the locals. (Palmetto.)

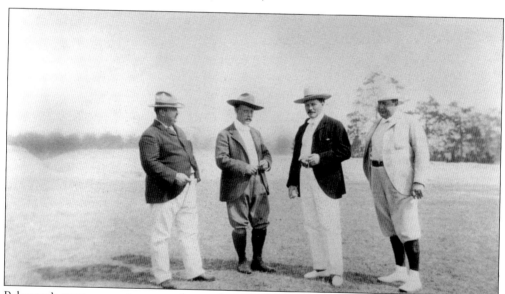

Palmetto's green committee was chosen from four different cities. From left to right, they are Herbert C. Leeds, a well-known champion from Boston who also helped design the course; Dr. Valentine Mott, a noted surgeon from New York who first introduced rabies vaccines in the United States; N. C. Simpkins of Washington; and C. M. Hinkle of Cincinnati. (Palmetto.)

This photograph of Palmetto Golf Club, taken in 1906, is from the personal album of Edward L. Smith, a Winter Colonist from New York and a member of Palmetto. He was noted for his ability to help arrange some of the "sporting amusements" for his fellow colonists. (Caroliniana.)

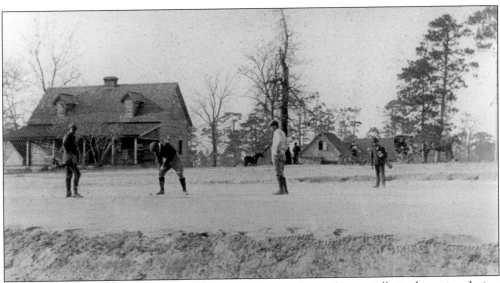

Caddies, or "golf boys" as they were called, were in great demand, especially in the spring during tournaments. Young black boys would often greet the trains to try and attach themselves to the known avid golfers as they arrived. The golf boys would often draw crowds as they performed tricks with balls and club to earn more tips. (Palmetto.)

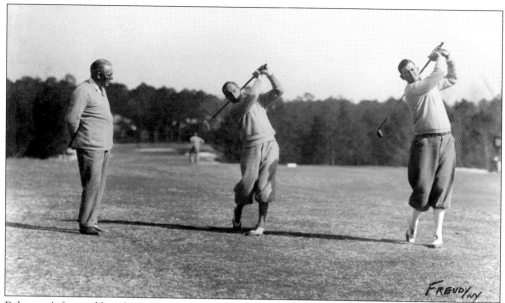

Palmetto's first golf professional was James "Jimmy Mackrell." Mackrell is shown here instructing two members on their swings. His contributions to Palmetto went beyond his golf skills, having helped design Palmetto along with Herbert Leeds. Mackrell served as Palmetto's pro for 42 years. (Palmetto.)

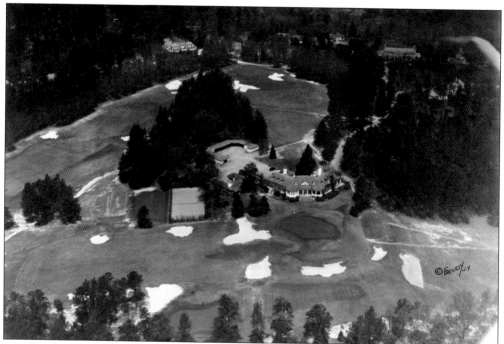

This Freudy aerial photograph shows Palmetto Golf Club sometime in the 1940s. The course has undergone several changes since then, including renovation and addition of locker rooms to the current pro shop and the addition of a driving range. Most noticeably, the tennis court in this picture was removed. The 18th fairway is much narrower, and the 18th green is now surrounded by bunkers. (Palmetto.)

The Highland Park Golf Club was built in 1912 adjacent to the grounds of the Highland Hotel. This photograph shows one of the par three holes. The stone steps up the hill still exist as a testament to its past, although some have washed away. Highland Park Golf Club was redesigned and reopened in 1999 under the name Aiken Golf Club. (Lista.)

Famed female golfers Mildred "Babe" Didrikson and Patty Berg, as well as actor/dancer Fred Astaire are only some of the names who have been written on the scorecards at Highland Golf Club over the decades. Didrikson is shown here on the course during the 1937 Women's Invitational. Patty Berg won the event. (ACHM.)

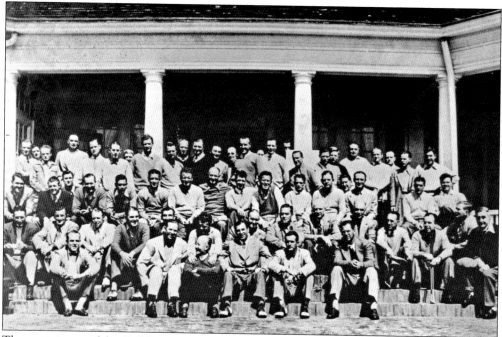

The participants of the 1947 Devereux Millburn Tournament are shown on the steps of Palmetto's Club House. Held the weekend before the Masters each spring, this was the second year the prestigious event had been held as a pro-am tournament, a tradition that continued only until 1953. Devereux Millburn Tournament was won by such notables as Ben Hogan, Byron Nelson, George Fazio, Henry Picard, and Lawson Little. (Palmetto.)

Shown here at Palmetto with Mary Rogers and Bing Crosby (right), Bobby Knowles was considered one of the country's best amateur golf players. Knowles was a Winter Colonist from Boston who came to Aiken in the 1930s when he was stationed in Augusta's at Camp Gordon. He's credited with changing golf's scoring vocabulary. Tracking players on a scoreboard, he showed who was above or below the first participants or "par." (Palmetto.)

Five

AIKEN AND ITS PEOPLE

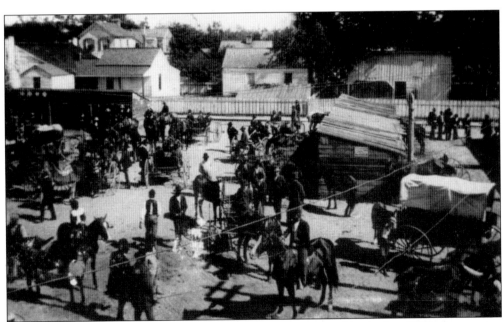

Even without its Winter Colonists, Aiken was an active city, and in the late 1800s, horses were used for far more than sport. Horse sales took place every Monday in an area called "Boneyard Alley" between Newberry and Laurens Streets and Richland and Park Avenues. Locals and visitors alike would go to an enclosure to buy and sell horses, tackle, and wagons. (ACHS.)

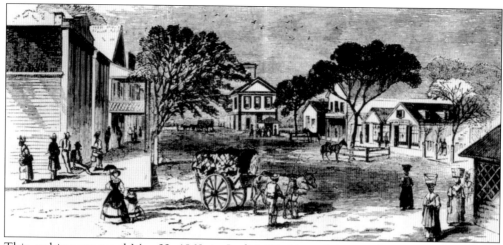

This etching appeared May 22, 1869, in *Leslie's Weekly* and depicts downtown Aiken after the Civil War. It shows Laurens Street and the business section with Aiken Town Hall in the background. The New York–based *Frank Leslie's Illustrated Newspaper* was a literary and news magazine published from 1855 to 1922. Artist Joseph Becker traveled extensively to illustrate for *Leslie's*, and Aiken was but one of his stops.

Also dating May 22, 1869, this drawing depicts a train arriving from the North into Aiken. It is labeled "Greetings from Mr. and Mrs. Frank Henderson." The Hendersons were a New York family who traveled to Aiken as part of the beginnings of the Winter Colony. Their son, also named Frank P. Henderson, would later help charter the Bank of Aiken and serve as town mayor.

While Coker Springs was the primary source of water in Aiken, there were several artesian wells located closer to the center of town. This photograph shows house servants retrieving water from one of those wells. Aiken Town Hall is seen in the background. In 1892, the city council approved the establishment of a central city waterworks that was located on Newberry Street. (Caroliniana.)

The land for Aiken's first Catholic church was purchased in 1853 at the corner of York Street and Park (Railroad) Avenue by the Right Reverend Ignatius A. Reynolds of Charleston. This wooden structure erected on brick pillars was not built until 1867 when Bishop Ignatio Persico came as a missionary following the Civil War. The building was destroyed during a storm just 10 years later. (Caroliniana.)

These stereographs are taken by J. A. Palmer, who moved to Aiken in the early 1870s. At a time when photography was first coming into its own, Palmer was a prolific picture taker. His images were not all stereographic, but these are the images that were most recognized as his work because he assigned a number to them, and a title and general description were written on the back. While he also took photographs of buildings, churches, street scenes, and landscapes, he was particularly interested in documenting scenes from the black community. The above images include what he referred to as "Aunt Betsey's Cabin," while the images below he labeled "Carrying Cotton To the Gin." A native of Ireland, Palmer first lived in Rochester, New York, and later Savannah before making the move to Aiken. (Above, Caroliniana.)

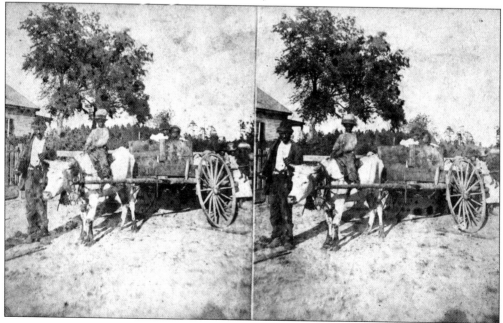

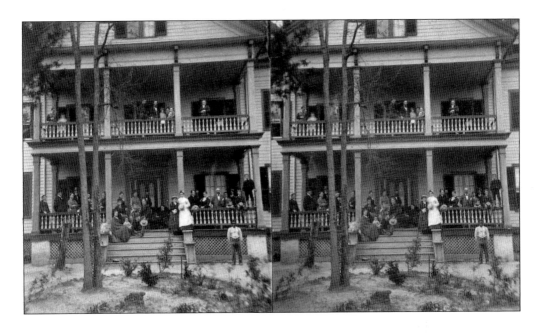

Palmer took these images of Dr. P. G. Rockwell's home in Aiken in April 1879. Rockwell was not only one of the town's doctors, he operated a boardinghouse and was mayor of Aiken in 1871 and 1872. Rockwell's home was located on Curve Street, and in the summer of 1874, he added 18 rooms to his home. The *Aiken Standard* reported that "He must expect an increase in visitors this season." It is estimated that Palmer printed stereographs of more than 1,000 images, selling them as souvenirs to those visiting. Palmer would also take photographs of news events in the area, even traveling to the Low Country to document the destruction from the 1886 earthquake. As his photography became more popular, he hired others to help in his work, including C. D. Hardt. (Both Caroliniana.)

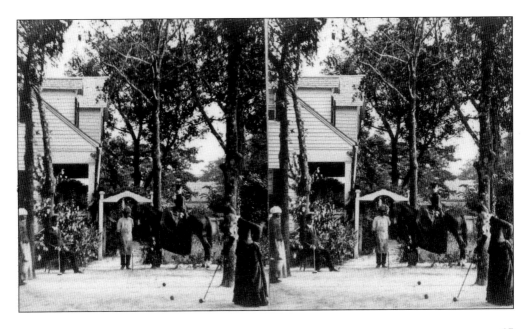

Martha Schofield had been working with The Bureau of Refugees, Freedmen, and Abandoned Lands, or "The Freedmen's Bureau," as a teacher for some time before health problems led her in 1870 to come to Aiken. Seeing a growing need for educating former slaves and their children, she used her own savings to buy 2 acres of land and laid out plans to establish her own school. (ACHM.)

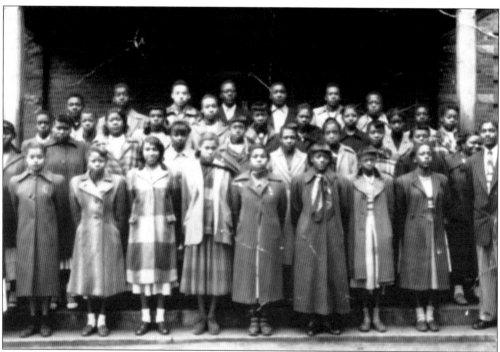

The Schofield Normal and Industrial School began its first classes in 1871. Every child learned basic reading, writing, and arithmetic, but work skills were equally important. Boys learned printing, carpentry, harness-making, and blacksmithing, while girls were taught housekeeping, laundry, sewing, and cooking. Earnings were applied to tuition and boarding. By 1896, Schofield School had 307 students, including 132 boarders. At its height, the school owned 281 acres and included a farm and two brick buildings. (Center for African American History, Art and Culture.)

In 1881, while serving as a missionary for the African American Presbyterian Missions for Freedmen, Rev. W. R. Coles came to Aiken with his wife and five children. He founded a church and a school in his rented six-room house. The Immanuel School expanded quickly, moving to its own building by 1882. Reverend Coles served as principal of the school until 1909. (CAAHAC.)

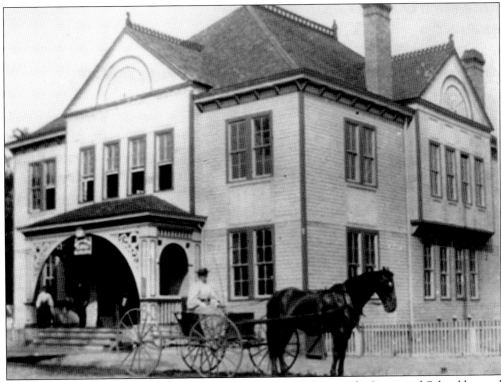

In addition to learning reading, writing, and arithmetic, students at the Immanuel School learned job skills such as sewing and carpentry. Music and piano were also taught. After Reverend Coles' departure in 1909, the school closed for two years before it was reopened in 1911 under Rev. James Jackson. Renamed the Andrew Robertson Institute, the school closed permanently in 1934. (South Carolina Department of Archives and History.)

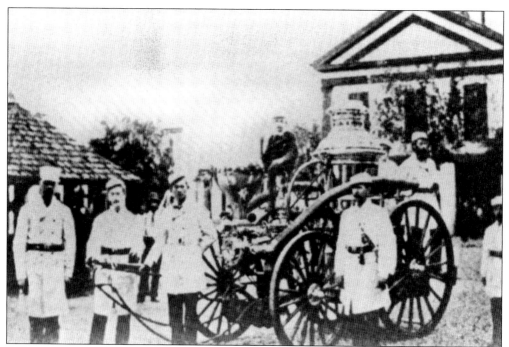

Aiken's first fire department was entirely voluntary, although firefighters were paid when they worked. Called the Aiken Hook and Ladder Company, it was started in 1873 with the help of W. C. Whitney, who often turned out for fires. The *Insurance Yearbook* that year proclaimed that Aiken County had a population of 2,362 and covered 640 acres. The department had 100 volunteers and one steam engine. Annual expenses were listed as $250. (ACHM.)

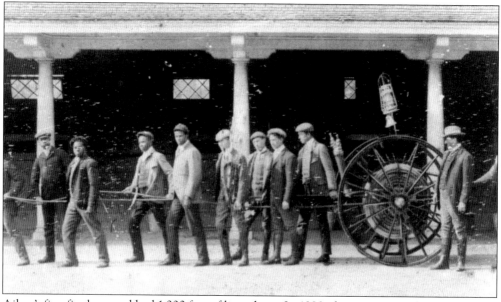

Aiken's first fire hose reel had 1,200 feet of linen hose. In 1888, the town council authorized the purchase of a second hose wheel, as well as a second hand pump to serve the black community. Because the city would reward whichever company arrived at the fire first, a rivalry sprang up between the two. (ACHM.)

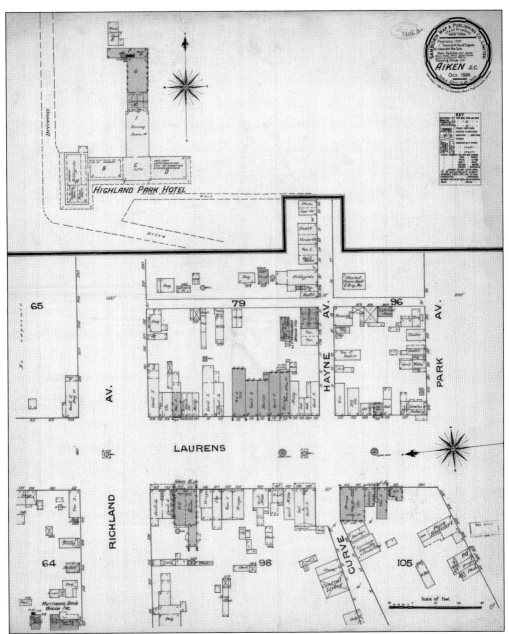

Dated October 1886, this Sanborn Company map was designed to assess fire insurance liability for part of downtown Aiken, as well as the Highland Park Hotel. The Sanborn Company was founded in 1867 in Somerset, Massachusetts, by cartographer Daniel Sanborn. His detailed maps quickly became a critical reference for towns and cities in evaluating their fire insurance needs, especially at a time when most buildings were constructed of wood. Between 1867 and 1970, more than 12,000 U.S. towns and cities relied on Sanborn's depictions of their buildings, which also described what building materials they were made of and the location of water sources. This map points out two wells and two fire cisterns in the middle of Laurens Street. The stamp in the corner acknowledges Aiken had a hook and ladder truck but labels the water facilities as "not good." Sanborn made new assessments of each city every year. (Caroliniana.)

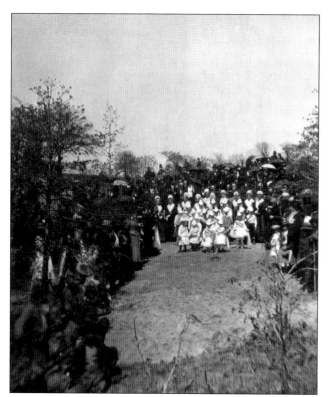

On April 16, 1876, citizens of Aiken held ceremonies on the grounds of the Highland Park Hotel to plant what was referred to as the "Centennial Tree." A special grafting of a pecan tree had been dubbed the Centennial Tree at the 1876 Centennial Exposition in Philadelphia. It is possible this was one of those trees. Participants attended wearing colonial costumes to mark the occasion. (Caroliniana.)

This photograph from the late 1870s shows efforts to plant trees along Park Avenue. Originally called Railroad Avenue, it was renamed Park Avenue in 1859 after the tracks were removed. Aiken's main thoroughfares were designed 150 feet wide to allow wagons with a team of six horses to turn unhindered. The broad avenues were fairly barren until 1877 when Dr. B. H. Teague began promoting the beautification and planning in the city's parkways. (Caroliniana.)

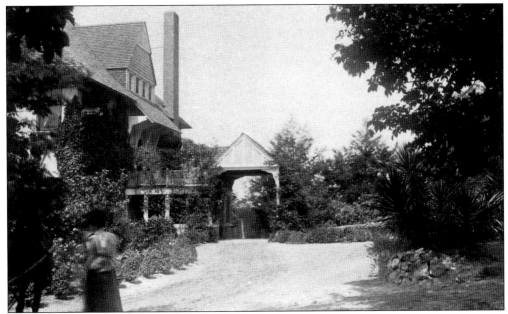

The 700-acre estate known as the Vale of Montmorenci was created by Henry M. Dibble. A Michigan native, he came to Aiken in the early 1870s for health reasons and opted to stay permanently. He succeeded Frank P. Henderson as president of the Bank of Aiken but was involved in numerous other business activities, including dairy farming. Dibble is credited with helping plant the live oak drive along South Boundary Avenue. (Caroliniana.)

Henry Dibble's daily 6-mile carriage ride from Montmorenci to Aiken via South Boundary Avenue is believed to have inspired the planting of the avenue's stately live oak canopy. Before this, South Boundary Avenue was rented out by the city as a garden plot. Dr. B. H. Teague's push to beautify the city proved a popular cause. Between 1877 and 1900, the Aiken Town Council authorized the planting of more than 500 hardwood trees. (ACHM.)

The Thursday Club was a literary organization begun in 1889 by sisters Mamie and Lizzie Ravenel, daughters of South Carolina planter, botanist, and agricultural writer Henry William Ravenel (1814–1887). In the early days, the club's emphasis was on travel, but in later years literary programs included settings and costumes. Native subjects and topics on current events also appeared more frequently. The club supported civil and educational projects in the community. The Thursday Club remained active for more than 55 years before finally disbanding in 1946. From left to right, they are Mamie Ravenel, Coralie Edgerton, Laura Edgerton, Rhetta Dow, Jennie Lou Browne, Alice Washburn, Video Legare, Mignon Brown, Maude Platt, Marianna Ford, Maria Edgerton, Mary Percival, Lulie Ford, Laura Carroll, and Lizzie Ravenel. (Caroliniana.)

This photograph of the Dorcas Society was taken on Easter Sunday 1889 on the steps of St. Thaddeus Church. The Dorcas mission was to help provide clothing and blankets to the poor. The group of women includes Tiplair Ravenel, H. "Etta" Ravenel, and Mamie Ravenel, who were also involved in the literary group known as the Thursday Club. (Caroliniana.)

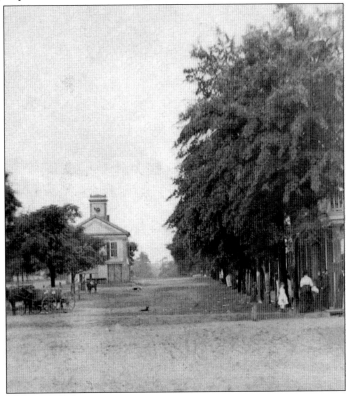

The Greek Revival–style building on the left in the distance was Aiken Town Hall. Located on Laurens Street between Park and Richland Avenues, the building had a large meeting area on the second floor and served numerous purposes for the community, including as a place for Sunday services before the Presbyterian church was built. This town hall was demolished in 1925. (Caroliniana.)

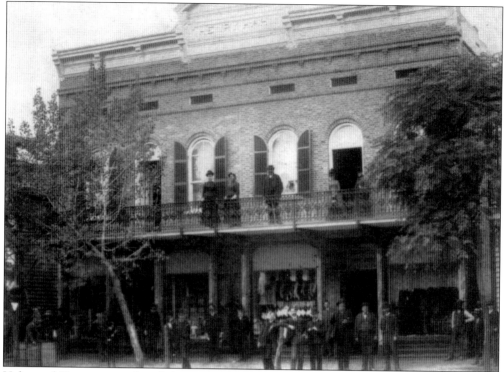

Hahn and Company was founded in 1865 at the corner of Laurens Street and Richland Avenue. As the company expanded, owner Henry Hahn built this building on the west side of Laurens Street in 1886. On its lower level was a high-quality grocery store touted as the finest in the South. It carried a large supply of gourmet goods to answer the demand of the Winter Colonists' refined palate. Store patrons could shop and Hahn's would deliver their groceries via horse and buggy. The store operated until 1953, but the building continued serving as one of Aiken's best-known commercial buildings until a gas explosion claimed it in 1956. An entrepreneur, Hahn also built the Aiken Hotel in 1898. (Both ACHM.)

Labeled "The Aiken County Savings and Loan," the Park Avenue building in this 1894 photograph would later be the Farmers' and Merchant Bank Building. The Highland Park Hotel is visible through the trees to the left. Electricity had only been in Aiken for about five years. South Carolina's first power company was Charleston Electric Light Company in 1886, followed a year later by the Congaree Gas and Electric Company in Columbia. (Caroliniana.)

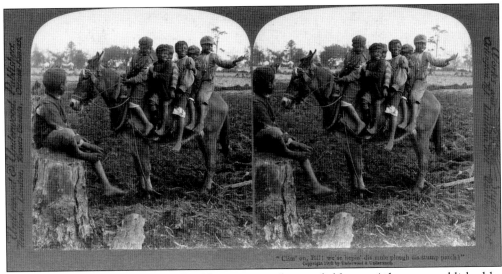

This late-1800s stereo photograph of boys on a mule in a field near Aiken was published by Underwood and Underwood. At one time, Underwood and Underwood was the largest publisher of stereo views in the world. Between the years 1854 and 1920, the company published more than 300 million views.

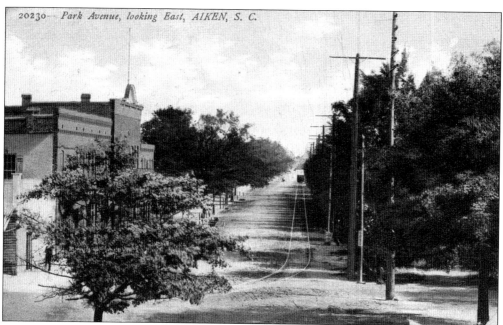

These early-1900s postcards of Laurens Street and Park Avenue show the interurban trolleys that operated between Aiken and Augusta between 1902 and 1929. The company was called the Augusta-Aiken Railway and Electric Company and was an expansion of the original service that had connected Augusta to the Hampton Terrace Resort in North Augusta. The wooden trolley cars were painted red and had 48 to 52 seats, each of them upholstered in cane. Their nicknames were "Big Reds." The cost to make the 26-mile, two-hour journey from Aiken to Augusta was 25¢. The service was a popular one until the advent of the automobile took its toll on ridership. The Augusta-Aiken Railway and Electric Company also owned two power plants, which furnished power to Augusta, North Augusta, Summerville, and Harrisonville.

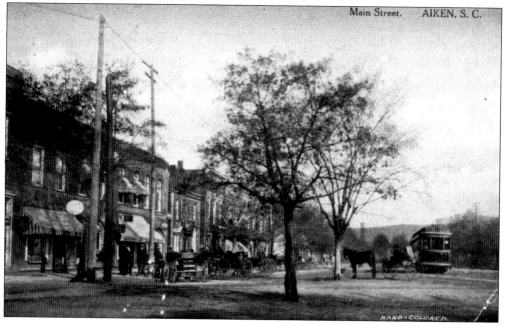

F. Christopher Johnson is shown leaning on the counter at Holley Hardware in about 1905. Johnson was one of Aiken's first blacksmiths and wheelwrights. Born in Denmark with the name Christian Jensen, he came to the United States by ship and eventually settled in Aiken. One of his customers was the City of Aiken, who used Johnson's blacksmith skills to maintain their horse drawn fire engines. (Lisa Hall.)

F. Christopher Johnson's advertisement for services (seen in the left column) appeared in the 1883–1884 *Southern Business Guide* with several other Aiken businesses. The guide was published in Cincinnati every two years and contained "the names, business, and address of the leading merchants, manufacturers and businessmen of the Southern States," as well as offering brief sketches of principal cities and villages of the South. (Lisa Hall.)

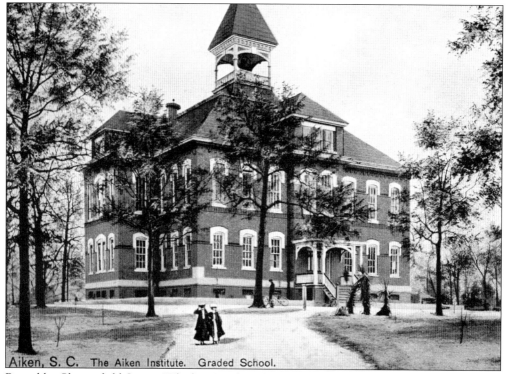

Bound by Chesterfield Street, Whiskey Road, Colleton Avenue, South Boundary Avenue, and York Street, the Aiken Institute helped give the area the name "Institute Hill." The Institute was chartered in 1888 and built in 1891. The D. S. Henderson Annex added to the southern portion of the building in 1914. Aiken Institute was home to grades 1 through 12 until 1936, when a new high school was built and this became Aiken Elementary School.

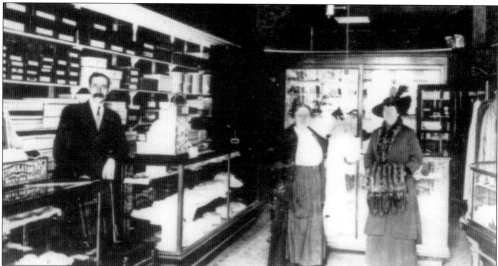

Shown here in 1915, Mrs. M. S. Polier's Millinery Shop made hats for the women of Aiken. The store was located on the west side of Laurens Street between Park Avenue and Hayne Avenue (previously called Curve Street). Just across Laurens Street and opposite the millinery shop was another Polier store that sold general merchandise. (ACHM.)

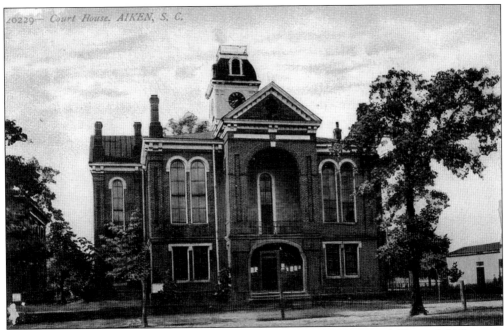

The Aiken County Courthouse was built on the corner of Park Avenue and Chesterfield Street in 1881, ten years after Aiken County was created. Before the building's construction, county offices had been located in a house on Colleton Avenue. Designed by Augusta architect R. W. McGrath, the redbrick building was constructed by builder J. W. Wood for a total of $12,733. In 1934, the building went through an extensive remodeling of its exterior. Architect Willis Irvin stuccoed over the brick and changed the cupola to allow for the addition of a clock, topping the structure with a weathervane. Although the courthouse underwent yet another renovation in 1987 when an addition was built, the original doors and brass locks are still in use in the main building.

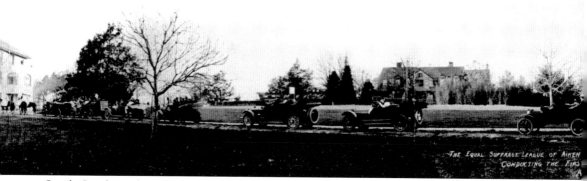

South Carolina's first parade organized in support of Women's Suffrage took place in Aiken on January 26, 1917. Conducted by the recently formed Equal Suffrage League of Aiken County, it was lead by Eulalie Salley. The first Equal Rights movement had begun in South Carolina in the 1890s, but it was not until 1912 when a concerted effort to gain women's right to vote truly began. The catalyst for many was the plight of a woman named Lucy Tillman. Lucy was married to the son

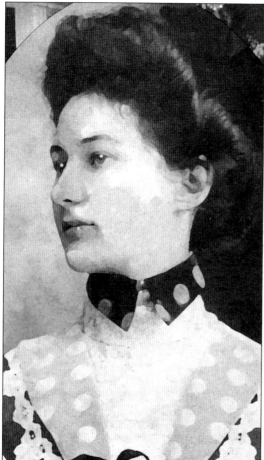

Eulalie Salley joined the South Carolina Equal Suffrage League in 1912 and helped organize the Aiken chapter. She became president of the state organization in 1919, the same year Congress ratified the 19th Amendment granting women the right to vote. The unflappable Salley spent the next 40 years traveling to national conventions and rallies while lobbying to get 36 states to ratify the amendment. (University of South Carolina–Aiken.)

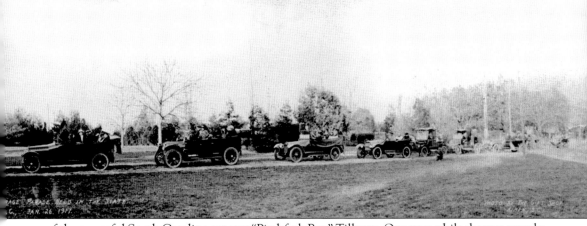

of the powerful South Carolina senator "Pitchfork Ben" Tillman. One year while she was gravely ill, her husband deeded her children to the care of his parents. Lucy sold everything she had and ultimately was able to get only limited visitation with her two daughters. The fact that children could be deeded as property stirred women to want to vote to change the law. (Caroliniana.)

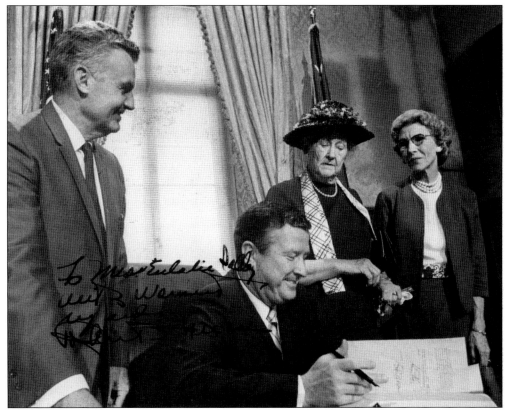

At the age of 85, Eulalie Salley was present July 1, 1969, when South Carolina governor Robert McNair signed the 19th Amendment into law. This is the picture he signed for her for the occasion. Of the 50 States in the Union, South Carolina was one of the last five to vote in favor of ratification. Only Georgia, Louisiana, North Carolina, and Mississippi took longer. (USC Aiken.)

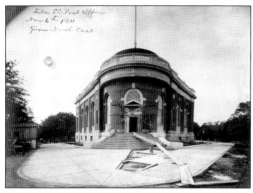 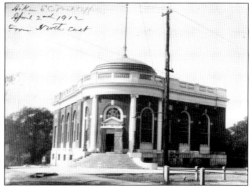

The Old Post Office was constructed on the corner of Laurens Street and Park Avenue between 1910 and 1912 at a cost of under $50,000. The above two photographs show the progress of construction from November 1911 to April 1912. At that time, Francis Hitchcock was the U.S. postmaster general. Hitchcock was the brother of Winter Colony resident Thomas Hitchcock. Previous post offices had been somewhat temporary. Aiken's first official office had been located in a store owned by Wiley Mosley. Later, Postmistress Maggie Carson ran the postal service out of her own home. From 1912 to 1953, the Aiken's National Weather Service observations were made from gauges just outside the post office's back door. Private owners purchased the building in 1971 after postal services were moved. Occupants have included Lista Studios (the building's owner), Aiken Technical College, U.S. senator Strom Thurmond's law offices, and the Savannah River Site's (SRS) management company. (Above, U.S. Department of the Treasury; below, Todd Lista.)

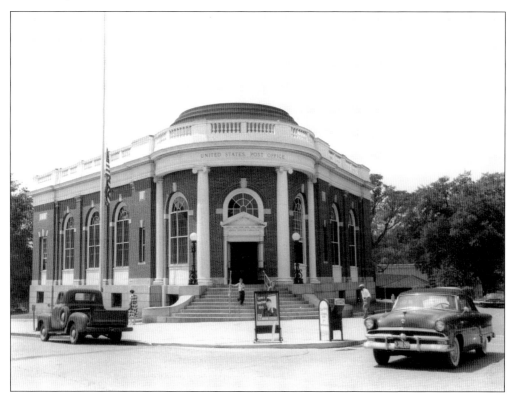

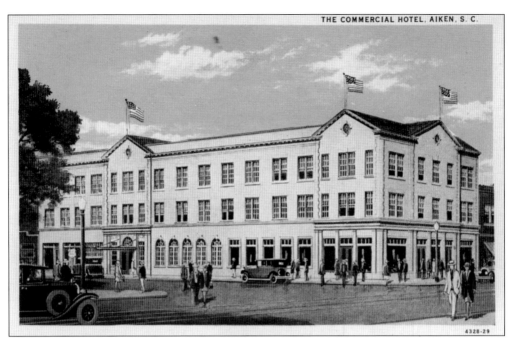

THE COMMERCIAL HOTEL, AIKEN, S. C.

The Commercial Hotel was considered the height of modern accommodations when it was built in 1929 by M. E. and B. F. Holley. Located on the corner of Laurens Street and Richland Avenue, the Commercial's big selling point was that it was "fireproof." With 50 guestrooms, most included private baths. The Commercial also boasted "an attractive lobby and dining room" on the first floor and assembly hall on the second.

In 1946, Jeane Cook (later Hall) is on the left on the street in front of the Commercial Hotel with two friends. Jeane was a waitress at the coffee shop located on the bottom floor of the hotel, but her career was short-lived. Feeling that the wait staff was underpaid, she organized a strike. She and her fellow striking staffers were fired. (Lisa Hall.)

Aiken marked its first centennial on April 4, 1935, with a two-day celebration. This program was assembled by historians and businessmen to mark the occasion. Inside, it contained the original Charter of Aiken, which was subtitled "an act to incorporate the Town of Aiken." Also recounted in its pages were key elements of Aiken's history from the early days through the Civil War and the founding of the Winter Colony. Polo Hall of Famer Devereux Milburn wrote the polo section. The introduction was written by Aiken Chamber of Commerce secretary Ernest Allen, who pointed out that Aiken had 6,600 year-round residents and almost 100 winter-homeowners. The city had two banks, many small industries, and what Allen referred to as a well-balanced business center "adequate to serve its growing needs." (JPT.)

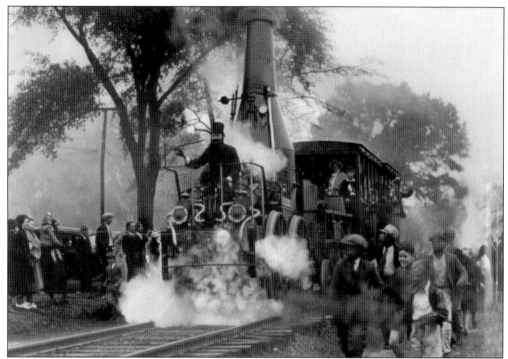

Part of the Aiken Centennial Celebration included a re-creation of the arrival into Aiken of the first steam engine. While the reenactment listed the train as "The Best Friend of Charleston," the real Best Friend never made it, having blown up two years before the Charleston–Hamburg rail line was completed. (Lista.)

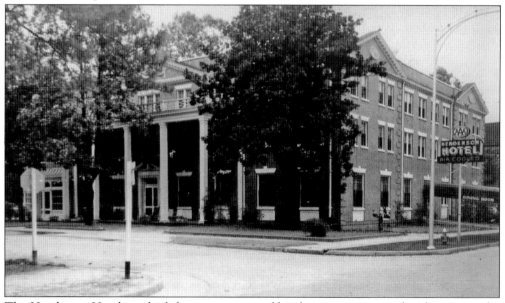

The Henderson Hotel was built by a committee of local citizens concerned with meeting the needs of Aiken's growing list of visitors. The grand opening was on January 1, 1930, with much fanfare. In 1960, the property was converted to the Palmetto Federal banking facilities. Its dining room was considered one of the finer restaurants in Aiken in the 1940s.

In the early 1900s, Aiken had two theaters, both located on Laurens Street and both with the same owner: H. B. Ram. The Patricia Theatre and the Rosemary Theatre were named after Ram's daughters. Opening October 23, 1938, with 700 seats, the Patricia was considered the more high-end theater. This photograph of the Patricia from 1940 shows the theater's preparations for the showing of Gone With the Wind. The film had opened in December 1939, but it took almost nine months to reach Aiken. The entrepreneurial H. B. Ram owned a real estate company and several buildings in the downtown area, including one simply called the Ram Building. The family made their home behind the Patricia. (Both ACHM.)

The woman seated below with the dummy is Sarah Ophelia Colley Cannon, better known to many as Grand Ole Opry star Minnie Pearl. In 1939, while working for an Atlanta-based tour group called the Wayne P. Sewell Production Company, Sarah directed a group of East Aiken High School girls in a production called *Black-eyed Susan*. The show for the Pilots Club at the Highland Park Hotel also led her to her first onstage performance as Minnie Pearl, having purchased her first "Cousin Minnie" costume from Ola Hitt and B. M. Surasky's store in downtown Aiken. From left to right, the chorus members seen above are Florence Staubs Usry, Christine Hahn Ropp, Helen Carswell Clamp, Martha Thorpe Grimsley, Rosamund Durban McDuffie, Sabri Hankinson Smith, Mabel McCoy Beasley, and unidentified. (Both ACHM.)

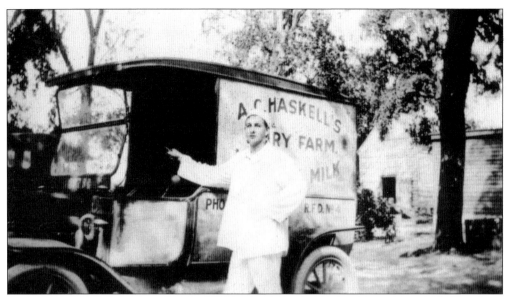

A. C. Haskell Dairy's clever poems on the backs of their milk bottles were created as a way to tout their product's benefits. The dairy was founded in 1912 by Alexander Cheves Haskell Sr. on 250 acres of land called the Woodlawn tract on Aiken Road near North Augusta. Mr. Haskell would only have Guernsey cows because their milk had a high butterfat content that was more nutritious. He marketed his milk as "nursery milk." Most pediatricians in the Aiken and Augusta area would recommend that mothers give their children Haskell Milk. During the 1930s, Haskell, his wife, son, and grandson wrote poems to put on their glass bottles, each espousing various benefits of their milk. Over the years, more than 30 poems were written, although not all made it onto the bottles. A. C. Haskell Dairy operated for 60 years. (Above, ACHM; below, photograph by RM.)

Aiken Recreation Club for Men in the Armed Forces, Aiken, S. C.

During World War II, this home operated as the Aiken Recreation Club for men in the Armed Forces. This postcard was sent by Pfc. George Davis to a friend in Ohio in 1943. Davis had been stationed at Camp (now Fort) Gordon, Georgia. He wrote that he had come to take a few pictures of Aiken, "but the big old trees almost obscure the town."

Aiken is the smallest community ever to have a U.S. military ship named for it. The SS Aiken Victory originally launched in 1944 and was later contracted by Mississippi Shipping. The U.S. Navy acquired USNS Aiken Victory (T-AP-188) in 1950 during the Korean War. She operated as a troop carrier in the Korean combat zone for 30 months before returning stateside. She was sold for scrap in 1971. (ACHM.)

Construction began in July 1951 at the U.S. Atomic Energy Commission's Savannah River Plant (late called the Savannah River Site). The AEC had announced on November 29, 1950, that they would build the facility to refine nuclear materials for deployment in nuclear weapons. The building and the operation of the plant came under the E. I. DuPont Company. (DOE.)

In building the Savannah River Plant, 310 square miles of land were bought under the power of eminent domain. The towns of Ellenton and Dunbarton and several other communities, including Meyers Mill, Leigh, Robbins, and Hawthorne, were displaced. Farms that had been owned by the same family for decades ceased to be. (DOE.)